POSTCARD HISTORY SERIES

Mount Holyoke
College

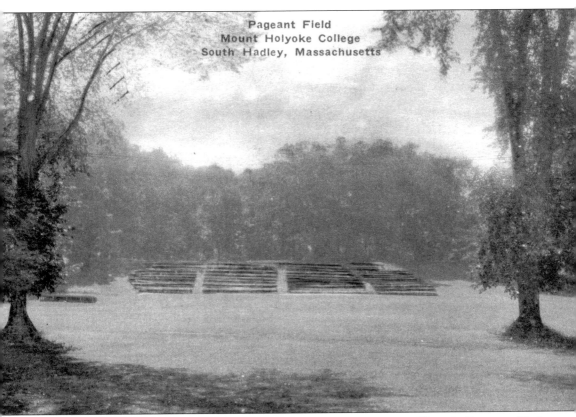

Pageant Field
Mount Holyoke College
South Hadley, Massachusetts

PAGEANT FIELD, POSTMARKED 1942. Inscription on the back: **Ensign Lillian G. Brannon U. S. Naval Mid School (WR) 318 S. Rockefeller Mount Holyoke College South Hadley, Mass Have thought of you so much & sorry I haven't had time to write—we just don't have a minute— Scheduled to get thru here on Dec 16th—Thanks so much for the diary—I started keeping it religiously but they made us destroy what we'd written—so I'll just have to tell you all about it sometime. The insignias, etc in front are coming in handy tho'—I have asked for further instruction at Radcliffe but don't know if I'll get it. Write me Love, Lillian.** During World War II, the navy set up a school for communications officers on campus, and Rockefeller Hall was the dormitory where the officers roomed. Several of the training officers assigned to the South Hadley "base" at Mount Holyoke were alumnae, but Lillian was not one of them. The stamp area is marked "Free," and the card was mailed without postage. (Published by the Albertype Company.)

POSTCARD HISTORY SERIES

Mount Holyoke College

Donna Albino

ARCADIA

Copyright © 2000 by Donna Albino.
ISBN 0-7385-0518-8

First printed 2001.

Published by Arcadia Publishing,
an imprint of Tempus Publishing, Inc.
2A Cumberland Street
Charleston, SC 29401

Printed in Great Britain.

Library of Congress Catalog Card Number: 2001086981

For all general information contact Arcadia Publishing at:
Telephone 843-853-2070
Fax 843-853-0044
E-Mail sales@arcadiapublishing.com

For customer service and orders:
Toll-Free 1-888-313-2665

Visit us on the internet at http://www.arcadiapublishing.com

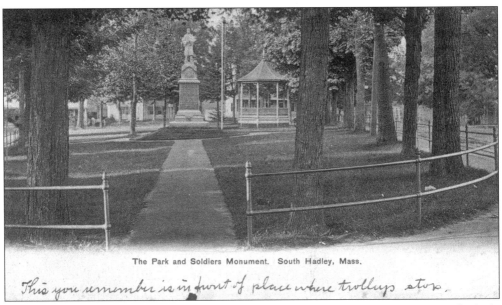

The Park and Soldiers Monument. South Hadley, Mass.

This you remember is in front of place where trollys stop.

THE PARK AND SOLDIERS MONUMENT, POSTMARKED OCTOBER 21, 1909. Inscription on the back: **Dear mamma—I will write before long, but haven't much time just now. Last night I went to Reception, but didn't dance. We had awful time finding our senior partners. I wore my graduation rig, and we had chocolate ice cream, ladies fingers and cookies with *green* frosting, and you know everybody eats with their silk and kid gloves on so I did and got some green on my thumb. When I got home I put the end of thumb in water and nearly all of it came out, so I guess it didn't hurt my gloves . . . Sat afternoon I go to Hygiene lecture from 3:50–about 5 . . . Wed. I was in labwork from 8:30 to about 11:30, most of all Monday then washing from 1:30 to about 3:30. I really would like you to see Vespers though . . . F.D. . . . I haven't written to Edith W. yet can't seem to find time to do anything.** This card was sent by Florence Parker Davoll x1913.

CONTENTS

Acknowledgments

I wish to thank Patricia Albright and Peter Carini of the Mount Holyoke Archives and Special Collections. They were extremely patient with me during my many visits to the college to research the women who wrote on these postcards, and I appreciate all their help and time more than I can say. Fred Kass and Michael Crowley generously supported me with disk space when my website of Mount Holyoke postcards swelled to unprecedented proportions, and I am grateful for their willingness to support my vision of making Mount Holyoke historical documents available on the World Wide Web. I am also delighted that Enis Turcan, a friend I met on the Internet, graciously supplied translations for the postcards that Leman Avni sent to her relatives in Turkey.

Two people, though, deserve special recognition and thanks for their roles in this project. Susan Greenleaf Anderson helped with research constantly during the past two years; I do not think I would have been able to accomplish half this book without her encouragement and willingness to help. Shawn Fields-Berry helped in so many practical ways, such as cooking for me and washing dishes, so that I could have more time to write. I bless both of them for their generosity and support, and I hope that I can be as helpful to them when they write their books.

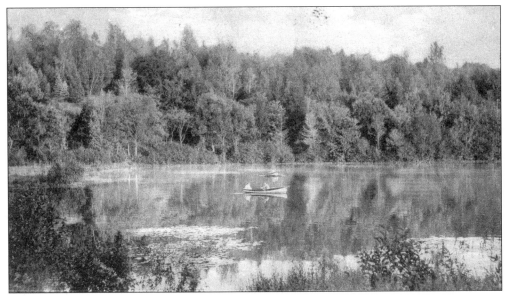

LAKE NONOTUCK (LOWER LAKE). Inscription: **Dear Sylvia, . . . Yesterday I paid the Zoo. Dept a visit in their new quarters . . . Miss Turner has taken the room under the chapel. Botany is partly in the Plant House. Mr. Hayes in the attic of Skinner. Miss Talbot in the Library, . . . The Senior Steps still remain & they are to build a temporary building one story . . . using the old foundations & walls. Best wishes M.A. Chase.** The recipient of the card was Sylvia L. Parker 1916. Abby Howe Turner 1896 was a professor of physiology. Samuel Perkins Hayes was a professor of psychology. Mignon Talbot taught geology and geography. Mabel Augusta Chase, the sender of the card, was an associate professor of physics. She refers to the aftermath of the Williston Hall fire of 1917 and the departments that had to be relocated. The temporary building she mentions was called "Little Willy," and it was built in 1918 from bricks salvaged from Williston Hall. It served as the science building until Clapp was built in 1923. It has been the Service Building since *c.* 1924.

INTRODUCTION

My postcard collection started in a little antique store on Cape Cod in 1985. I was browsing through paper items on a table when I pulled out a postcard of a familiar scene: a waterfall on the campus of my dear alma mater, Mount Holyoke College. It was postmarked 1909, addressed to a woman named Carrie, and was inscribed as follows: "I visited Mt. Holyoke College last Friday and had a fine time. There are about 700 girls up there. Yours sincerely Julia." I was instantly enchanted. What had Julia done while she was at Mount Holyoke? Whom had she visited? Where did she stay? Who was Carrie?

I found more cards for my collection, many of them postally used. I enjoyed reading them and grew curious about the women who wrote and received them. Some had clues to help identify the author: a dorm she lived in, her initials, a family surname. I compiled a list of the most promising clues and went to the Mount Holyoke Archives to see if I could identify my "postcard ladies."

That trip to the archives was the first of many. From research material there, I was able to identify quite a number of the "postcard ladies." Much to my delight, I was also able to unravel some of the stories they talked about on their postcards. A visit by President Taft, Freshman Frolic, juniors spinning tops—the archives had materials describing all these events and many more besides.

My collection now consists of more than 1,100 postcards. Many are beautiful, unused postcards. However, the postcards I find most interesting are the ones that were inscribed and mailed to friends and family, and saved as treasures by their recipients. They are often battered, chipped, or worn at the edges from many years of being handled and read. These cards offer more than just a view of a building that may or may not exist today; they offer a glimpse into life at Mount Holyoke. I hope this book works like these postcards; you first opened the book to see the pictures, but I hope the messages associated with the images will charm you as well. If I was able to identify someone mentioned on the postcard, I included that information. "Hannah Noble 1858" means that Hannah graduated in 1858, and "Florence Davoll x1913" means that Florence was a nongraduating member of the Class of 1913.

The college began in 1837 as a seminary for working-class women who were interested in serving as missionaries or teachers around the world. All students had to do unpaid domestic work for the seminary to keep the tuition costs low. By the 1890s, the seminary had transitioned into a college, but the spiritual life at Mount Holyoke was still very important to the students and faculty.

Most of the postcards in this collection were sent during Mary Woolley's 37-year presidency at Mount Holyoke. This was a time when Mount Holyoke worked for a reputation as a top-ranked college for women, especially for women in the sciences. Mary Woolley continued to urge students to consider careers as missionaries, thus honoring the institution's original vision as a seminary, but she was also dedicated to redesigning the curriculum and developing the faculty to face the more rigorous academic standards of a college.

Sixteen new buildings were constructed during Woolley's tenure, and two were destroyed by fire. Postcards sent during this time reflected great pride in the natural beauty of the campus and its new buildings, and mentioned the ones lost to fire. Some of the older postcards mention faculty living in the dormitories before these new buildings were erected. Social events and clubs became more popular than they had been during the seminary days, and many of the student traditions that were mentioned in postcard inscriptions began during Woolley's tenure. The first May Day pageant and the first play on Prospect Hill, for instance, were part of the Woolley presidential inauguration in 1901.

Students at the college during the postcard era showed devotion to their studies. Many of their messages complained about the workload and how their academic and social commitments kept them too busy to write long letters. Students traveled frequently between the colleges in the area, visiting hometown friends who were in nearby schools. They looked forward to their friends visiting Mount Holyoke as well, and their visitors also sent happy cards home to their families.

Love for the college never ended with graduation. Alumnae, faculty, and staff sent many cards to each other. Sometimes they shared the enthusiasm of reunion activities. Other times it was a summer visit to a quiet campus. Always visible were the pride in the college and the warmth of the friendships that had begun there. I hope you will enjoy reading the words of these Mount Holyoke women and refreshing your own fond memories of life at Mount Holyoke.

—Donna Albino
January 20, 2001

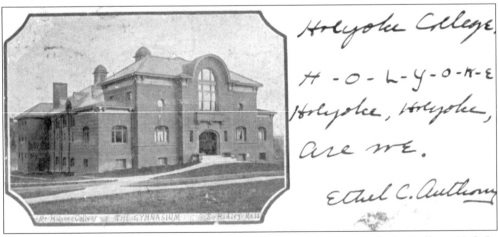

THE GYMNASIUM, POSTMARKED JUNE 9, 1903. Inscription on the front: **Holyoke College. H-O-L-Y-O-K-E Holyoke, Holyoke, are we. Ethel C. Anthony.** This card was sent by Ethel Catharine Anthony 1906, and the quote she uses on the card was from a popular college song.

8

One

"I'VE ARRIVED SAFELY"

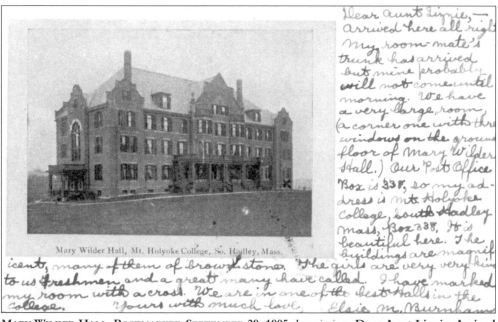

MARY WILDER HALL, POSTMARKED SEPTEMBER 29, 1905. Inscription: **Dear Aunt Lizzie, Arrived here all right. My room-mate's trunk has arrived but mine probably will not come until morning. We have a very large room (a corner one with three windows on the ground floor of Mary Wilder Hall) . . . It is beautiful here. The buildings are magnificent, many of them brownstone. The girls are very very kind to us Freshmen and a great many have called. I have marked my room with a cross. We are in one of the best Halls in the college. Yours with much love, Elsie M. Burnham.** Elsie May Burnham 1909 roomed with Marion Annie Sayward 1909 in 7 Wilder that year.

THE BROOK (BETWEEN UPPER AND LOWER LAKE), POSTMARKED NOVEMBER 29, 1910. Inscription: **Well, I arrived here safely at 9.00 am. pretty sleepy. Enjoyed my breakfast very much. Finished up the fire after dinner. Have put my hat in the hat box and am going to put the green hat down in my little trunk. How are you to-day? Love, Edith.** The sender was Edith Cornelia Tracy x1913.

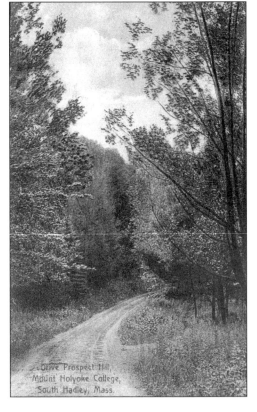

THE DRIVE AT PROSPECT HILL, POSTMARKED APRIL 18, 1911. Inscription on the back: **Dear Edith, Wish you could have been with me for the rest of the way. The Berkshires were beautiful that day. and the train boy was quite respectful. I became very dignified. Coming back as far as Syracuse, Thurs on train No. 3. Belle C. South Hadley, Mass. April 17.**

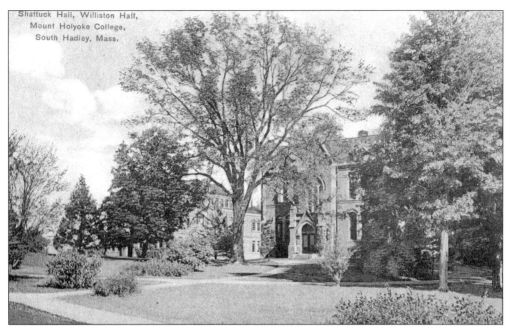

Shattuck Hall, Williston Hall,
Mount Holyoke College,
South Hadley, Mass.

SHATTUCK AND WILLISTON HALLS, POSTMARKED SEPTEMBER 21, 1910. Inscription: **Dear Aunt Sarah: We arrived here safely last evening about eight o'clock. We had a very nice trip. I met a girl from Livonia on the train, she was going to Smith College. Grace Rotzel is not on campus, she is at Mrs. Winchester's, that is a very nice place to be . . . Love from Clara.** Clara Loretta Marr 1912 writes about her friend Grace Augusta Rotzel 1913. Mrs. Winchester's home on College Street was used for student housing.

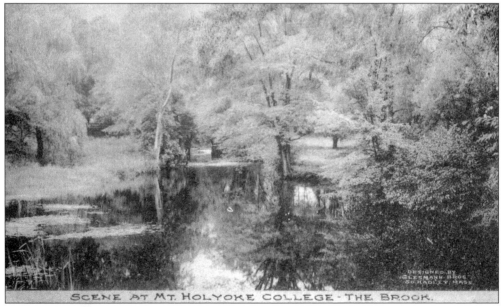

SCENE AT MT. HOLYOKE COLLEGE - THE BROOK.

THE BROOK, POSTMARKED SEPTEMBER 25, 1908. Inscription on the front: **Dear mother, In the excitement I neglected to write to you that I got here all right. met Adele on the train. College is great. Love from Adelaide.** Adelaide Helena Bolton 1910 worked as an artist in Philadelphia after graduation.

11

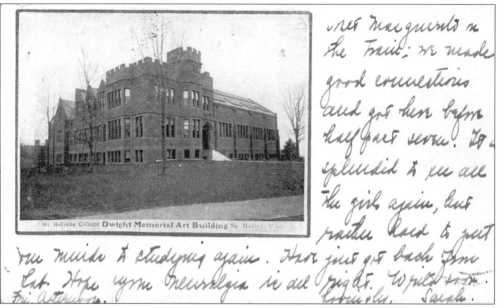

DWIGHT MEMORIAL ART BUILDING, POSTMARKED APRIL 14, 1905. Inscription: **Met Marguerite on the train; we made good connections and got here before half past seven. It is splendid to see all the girls again, but rather hard to put the minds to studying again. Have just got back from Lab . . . Lovingly, Sarah.** Sarah Keese Arnold 1907 taught art at Mount Holyoke after graduation. Her mother and sister were also Mount Holyoke women.

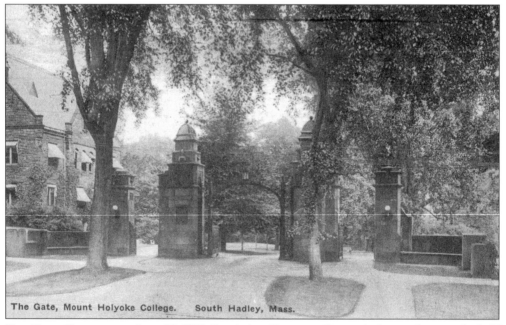

THE GATE, POSTMARKED JUNE 12, 1922. Inscription: **Dear . . .: Our train lost an hour and a half but I got here in time for lunch. While I was waiting for a street car in Holyoke two ladies picked me up in their car. It rains pitchforks every few minutes then the sun comes out bright and hot. With . . .** The names and the address have been erased.

12

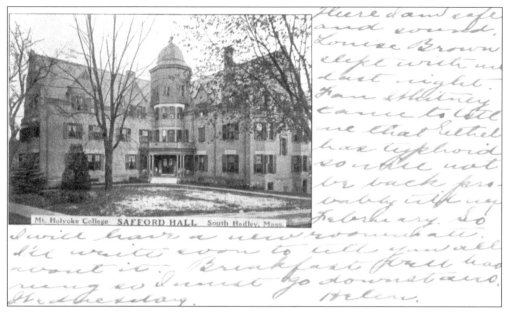

SAFFORD HALL, POSTMARKED SEPTEMBER 14, 1904. Inscription: **Here I am safe and sound. Louise Brown slept with me last night. Fran Whitney came to tell me that Ethel has typhoid so will not be back probably till next February. So I will have a new roommate. I'll write soon to tell you all about it. Breakfast bell has rung so I must go downstairs. Wednesday. Helen.** Helen Emma Wieand 1906 sent this postcard. She mentions Louise Brown x1907, Frances Rebecca Whitney 1908, and Ethel May Sevin 1906.

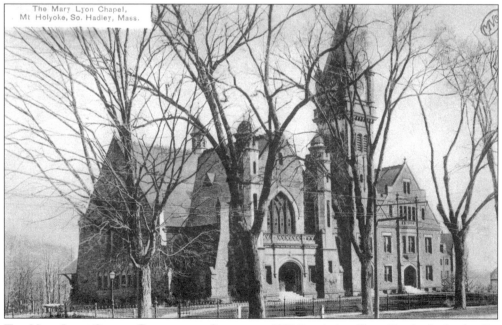

THE MARY LYON CHAPEL, POSTMARKED SEPTEMBER 1915. Inscription: **Dear Carrie: Arrived at So. Hadley at 8 o'clock prompt. [Freda] very nearly losing our car at Amherst. Had to run for it. It is beautiful here. We have a good room. Lovingly, Faith.** Faith Evelyn Harris 1919 lived in 18 Cowles Lodge with Freda Marie Harris 1919.

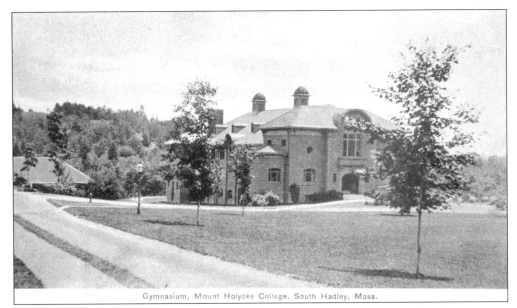

Gymnasium, Mount Holyoke College, South Hadley, Mass.

THE GYMNASIUM, POSTMARKED SEPTEMBER 21, 1910. Inscription: **This Gymnasium is next to my hall. Arrived here all right. Having a splendid time but rather lonesome, as my room-mate has not come. I'm rather mixed up about things but I'll get along soon. With love, Esther.** Esther Wallace Bicknell 1914 sent this postcard. Esther's roommate was Ruth Rogers 1914, who was coming to Mount Holyoke from Kansas. They lived in 45 Porter that year.

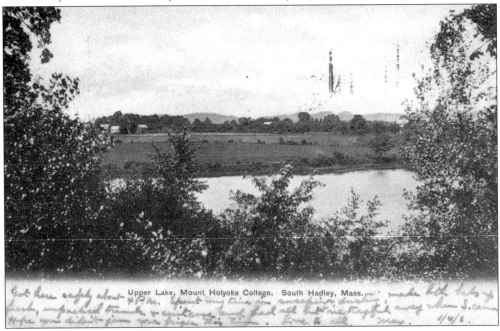

Upper Lake, Mount Holyoke College. South Hadley, Mass.

UPPER LAKE, POSTMARKED JANUARY 4, 1906. Inscription: **Got here safely about 4 P.M. Spent my time in sweeping, dusting, made both beds up fresh, unpacked trunk & suitcase, and had all but one trayful away when S. came. Hope you didn't jam your finger this time. Love to all, May. 1/4/6.** Mary Warren Shepard 1908 was the sender of this card. After graduating she served as a missionary in China.

14

MANDELLE HALL, POSTMARKED SEPTEMBER 24, 1945. Inscription: **Dear Alec, Well what do you know—I wrote before a year was up—even if only a card!! Soon as I'm settled will write more. Can't believe the old grind is beginning! Too soon! Be good Love Lois.** (Published by Mount Holyoke College Bookstore.)

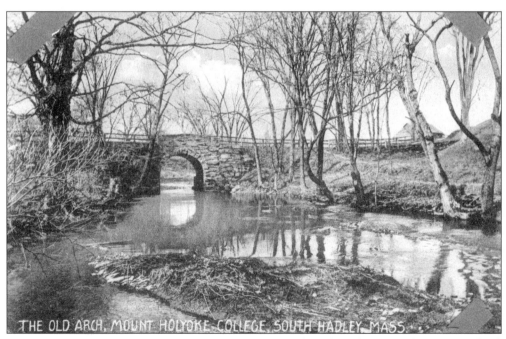

THE OLD ARCH, POSTMARKED JUNE 16, 1915. Inscription: **I have been having a glorious time back here again with all the girls. Thanks to you my dresses were in fine condition when I got here. With love, Harriet. My love to your mother.**

Can Edith send me the Mt. Hermon College South Hadley postcards I sent her?

THE DRIVE, POSTMARKED APRIL 23, 1908. Inscription: **It is very warm . . . the girls were out on the campus playing ball when I arrived. Arrived safely at 5:30 P. M. Adah met me in Springfield. Had a very pleasant journey back . . . Have been talking about the wedding since I arrived. My trunk will come tomorrow. Love from Mary.** Mary Poole Haskell 1908 sent this postcard.

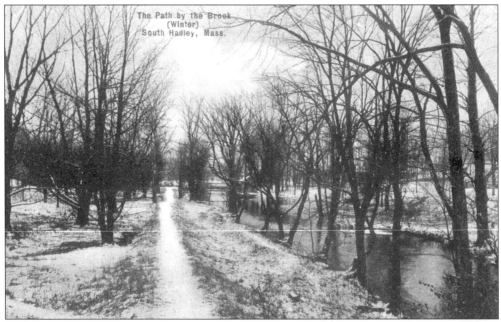

THE PATH BY THE BROOK (WINTER), POSTMARKED FEBRUARY 23, 1910. Inscription: **Good morning Mother mine: Lots of new snow out here—everything is covered and beautiful to behold. I arrived safely at expected time. Mr. L____ met me. Wrote to H____ on train; tried to do papers last night but was sleepy & went to bed at nine instead & rose at 5:30 this morning— rather different from Monday! . . . Lovingly, R.**

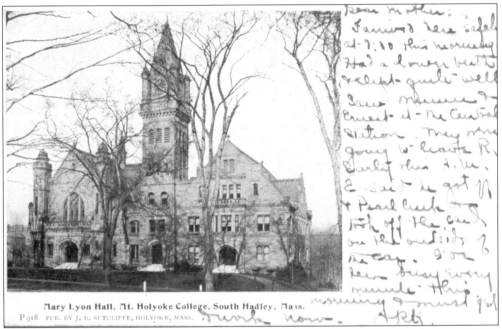

Mary Lyon Hall, Mt. Holyoke College, South Hadley, Mass.
P 918 PUB. BY J. B. SUTCLIFFE, HOLYOKE, MASS.

MARY LYON HALL, POSTMARKED JUNE 7, 1906. Inscription: **Dear Mother:—I arrived here safely at 7:30 this morning. Had a lower berth & slept quite well. Saw . . . Ernest at the Central Station . . . he got N & Pearl back & took off the card on the outside of the car. I've been busy every minute this morning & must get to work now. A.R.H.** Agnes Ruth Hammond 1907 sent this postcard.

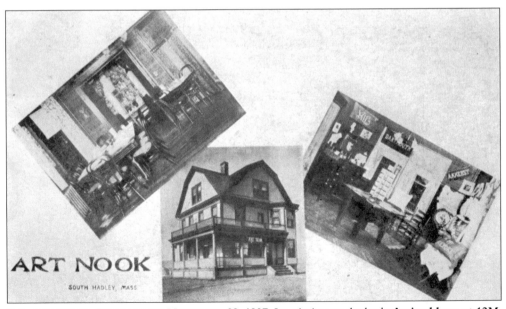

ART NOOK
SOUTH HADLEY, MASS.

THE ART NOOK, POSTMARKED NOVEMBER 29, 1907. Inscription on the back: **Arrived here at 12M. to-day. Have had a pleasant time so far. Hope you reached home all right & in good time. Home to-morrow. E.** The Art Nook, shown in one exterior and two interior views, was a popular student hangout on College Street.

THE FIELD MEMORIAL GATEWAY, POSTMARKED SEPTEMBER 22, 1914. Inscription: **This is the gate I entered last night. I registered at once in building at left, my room is in the one at right. I was so tired and never so dirty in my life. Tell Mother my lunch was grand and I had bushels and have lots left now . . . Love Edith.** Edith J. Nash x1918 lived in 47 Brigham that year.

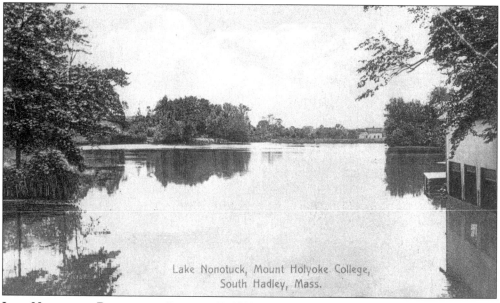

Lake Nonotuck, Mount Holyoke College, South Hadley, Mass.

LAKE NONOTUCK, POSTMARKED JANUARY 10, 1910. Inscription: **Dear Aunt Sarah:—Gertrude and I arrived safely but we had such a long tiresome trip owing to delayed trains. We didn't leave Rochester until 11:45 and consequently we didn't arrive here until nearly midnight . . . I wish you would write to me . . . letters from home are always so welcome. C.L.M.** Clara Loretta Marr 1912 sent this postcard.

WILLISTON LIBRARY, POSTMARKED OCTOBER 3, 1949. Inscription: **Fri. Dear Ted—Finally I'm here—and plunged right in to work. I told Syl. Sandberg your address & no doubt she will call you sometime. Say hello to Ray. Cathy.** (Published by Mount Holyoke College Bookstore and the Albertype Company.)

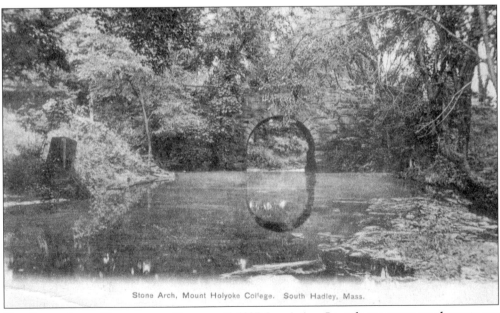

Stone Arch, Mount Holyoke College. South Hadley, Mass.

THE STONE ARCH, POSTMARKED OCTOBER 7, 1907. Inscription: **I surely meant to get down to see you before I came back; but the usual excuse of much to do at the last moment accounts for my negligence. The year has begun already to promise to be a busy one, as well as happy. We have not yet appeared in cap and gown; but hope to soon. Then I suppose we will begin to feel grave and reverend . . . Love from [signature].**

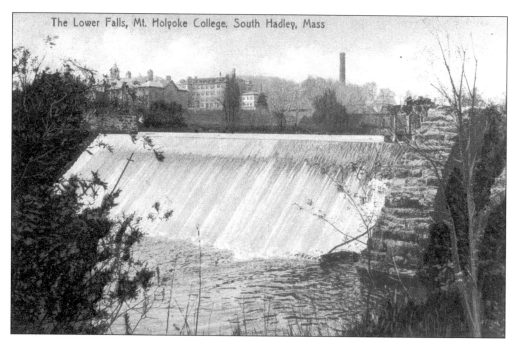

THE LOWER FALLS, POSTMARKED SEPTEMBER 19, 1911. Inscription: **Dear Aunt Hattie:—I got here without losing my purse or suitcase or umbrella and found my room all newly papered. It looks just lovely. I wish you could see it. Every one is more than excited to get back & we are having great times meeting the new girls . . . J. A.**

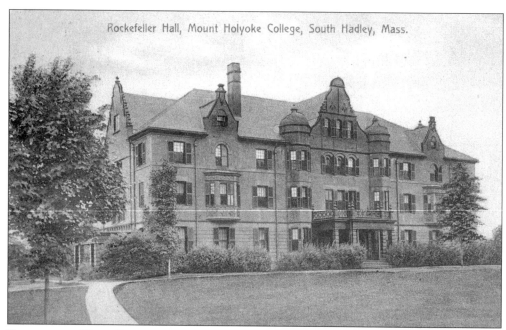

ROCKEFELLER HALL, POSTMARKED OCTOBER 2, 1911. Inscription: **Dear Aunt Hattie:—I am all settled here and hard at work. I like everything and everybody very much. Am going to try to write a letter before long and tell you all about the college. Love to all the folks. Your niece, Ruth.**

Two
"I LOVE IT HERE!"

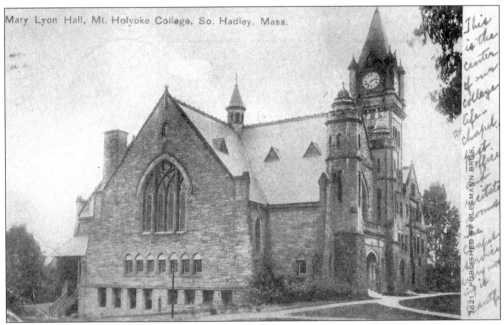

Mary Lyon Hall, Mt. Holyoke College, So. Hadley, Mass.

This is the center of our college life—chapel, post office, and recitation rooms. 7621 PUBLISHED BY LEE MANN BROS.

MARY LYON HALL, POSTMARKED OCTOBER 13, 1913. Inscription on the front: **This is the center of our college life—chapel, post office, and recitation rooms. The chapel service every morning is beautiful.** Inscription on the back: **Thank you for your card. I am so glad you are enjoying the work and good health, too. Mount Holyoke is a wonderful place, and I am learning to love it more every day, altho' the work is pretty hard. I have a little single room on 4th floor, and am very comfortable. The upperclass girls are all so nice to freshmen; there are about 90 girls in this hall, Rockefeller. Your loving friend Sarah L. Cornwell.** Sarah Louise Cornwell 1917 lived in 48 Rockefeller that year.

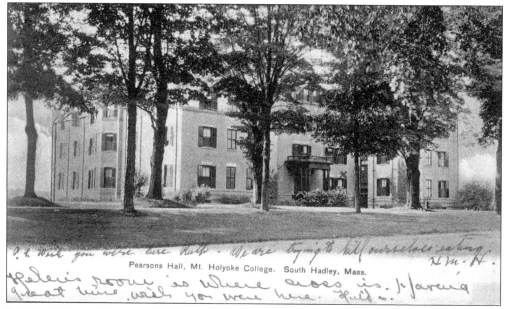

Pearsons Hall, Mt. Holyoke College. South Hadley, Mass.

PEARSONS HALL, POSTMARKED NOVEMBER 25, 1909. Inscription on the front: **Helen's room is where cross is. Having a great time, wish you were here. Hilda. P. S. Wish you were here Ruth. We are trying to kill ourselves eating. H.M.H.** Helen MacFarland Hett 1912 lived in 5 Pearsons that year. Note the window on the first floor to the right of the entrance that is marked with an X.

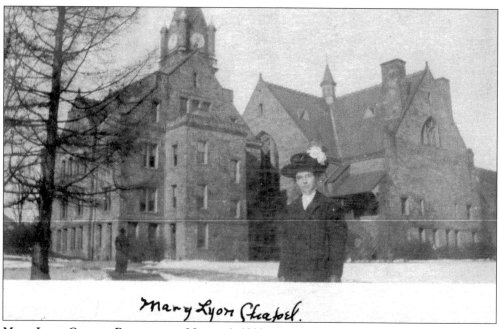

Mary Lyon Chapel.

MARY LYON CHAPEL, POSTMARKED MARCH 1, 1911. Inscription: **Tues. Eve. Will you please look in your [. . .] to see if you have a letter in there for me. I have not received my home letter this week so I am afraid mother is sick or you are guilty. Had a grand spread to-night and heaps of fun. Ethel.** Ethel Marion Cutts x1914 was the author of this card.

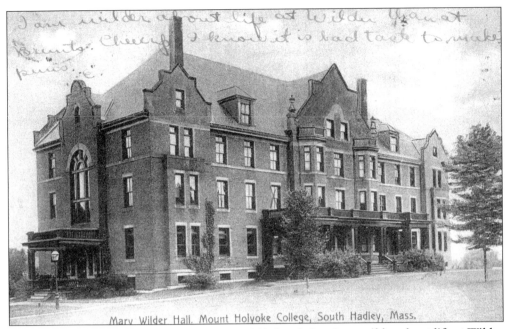

MARY WILDER HALL, POSTMARKED APRIL 14, 1912. Inscription: **I am wilder about life at Wilder than at Brunts. Cheer up I know it is bad taste to make puns. I have a dandy senior room. The cross marks Mary A's room and mine is on the rear . . . I have a wonderful view of the lake and "Prospect." E.** Edith Isabel Woodruff x1915 started the year living at Mrs. Brunt's and transferred to Wilder. Mary Emily Abrams 1913 lived in 50 Wilder, the second-floor room that is marked.

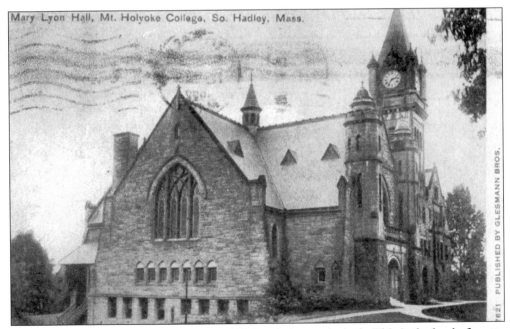

MARY LYON HALL, POSTMARKED MAY 1, 1922. Inscription on the back: **This is the land of pretty girls and fine horses. [Signature].**

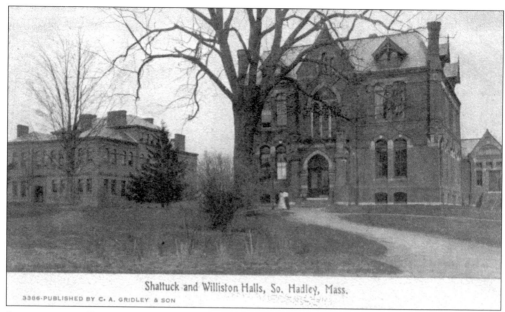

Shattuck and Williston Halls, So. Hadley, Mass.

3386-PUBLISHED BY C. A. GRIDLEY & SON

SHATTUCK AND WILLISTON HALLS, POSTMARKED SEPTEMBER 30, 1910. Inscription on the back: **It is perfectly lovely here. Only my trunk isn't here yet, so I haven't settled. There are about 18 girls in this house. My room-mate won't be here till Mon my books haven't all come, so haven't studied much. with love. Gretchen.** Gretchen Frieda Barr 1911 was the sender of this card.

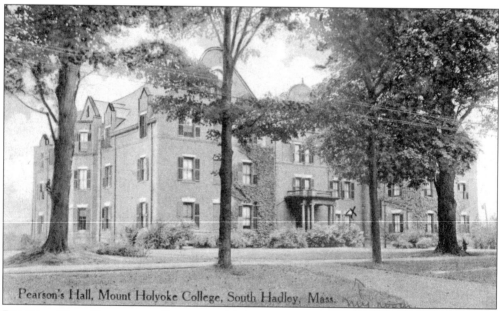

Pearson's Hall, Mount Holyoke College, South Hadley, Mass.

PEARSONS HALL, POSTMARKED SEPTEMBER 24, 1912. Inscription: **Was real glad to get your card. Believe me I'm having the time of my young life. Am planning a mid night spread!! I heard from Helen that you're having some doings too. Would like to hear the news. Edith G.** Edith M. Gates x1917 lived in 5 Pearsons that year. The window on the first floor is marked with the words "my room."

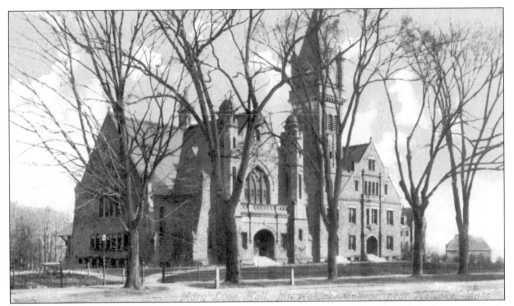

MARY LYON HALL, POSTMARKED OCTOBER 10, 1912. Inscription: **I like Mt. Holyoke very much and am having a fine time here. The 75th anniversary exercises are just over. Glad to get to work again. My roommate is very nice and I like her very much. Do write and tell me how the children like kindergarten. Love Winifred Allen.** Winifred Florence Allen 1916 sent this postcard.

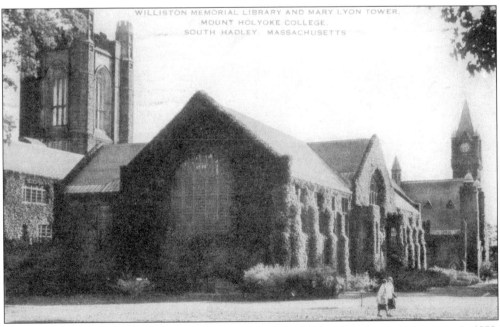

WILLISTON MEMORIAL LIBRARY AND MARY LYON TOWER, POSTMARKED NOVEMBER 6, 1958. Inscription: **The hoola-hoop has even invaded Mount Holyoke. I'm getting pretty good from all the practice. Believe it or not, I work pretty hard too but I just love it here. I hope to see you during vacation. Sincerely, Jean Colyer.** The sender was Jean Colyer 1962. (Published by Artvue Post Card Company.)

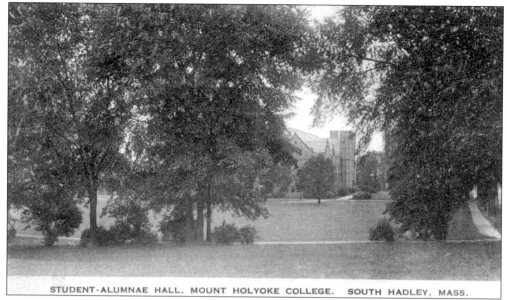

STUDENT-ALUMNAE HALL, MOUNT HOLYOKE COLLEGE. SOUTH HADLEY, MASS.

STUDENT-ALUMNAE HALL, POSTMARKED SEPTEMBER 21, 1923. Inscription: **Dear Grace, It's perfectly wonderful here. I'm in the new dormitory and I'm simply wild about it. Classes began this morning. There's a party tonight and a reception tomorrow. Keeps me quite busy . . . Love, Felma.** Felma A. Pratt 1927 lived in 224 North Hillside (later known as North Mandelle). Student-Alumnae Hall was renamed Mary Woolley Hall in 1945.

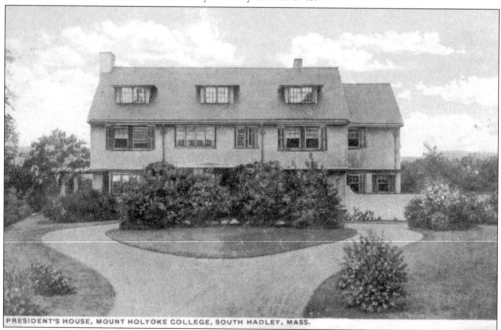

PRESIDENT'S HOUSE, MOUNT HOLYOKE COLLEGE, SOUTH HADLEY, MASS.

THE PRESIDENT'S HOUSE, POSTMARKED SEPTEMBER 25, 1920. Inscription: **Dear Elsie,—College is certainly wonderful!!! Everyone who has seen my couch cushions, thinks the Wohelo one is the best. I have met 2 Camp Fire girls and they are lovely! We began regular lessons to-day, & it's very thrilling. I'm going to a party now so will stop. Love, Ruth H.** Ruth Gladys Holton 1924 was the author of this card.

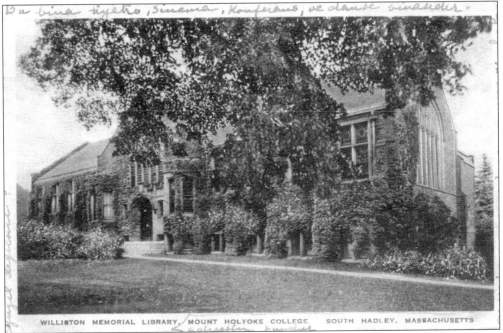

WILLISTON MEMORIAL LIBRARY, MOUNT HOLYOKE COLLEGE SOUTH HADLEY, MASSACHUSETTS

WILLISTON MEMORIAL LIBRARY, POSTMARKED DECEMBER 2, 1933. Translated Turkish inscription: **1/12/1933 My dear uncle . . . Here is like paradise. I am very tired, because I have to do my homework for college. How are you? I wait for your letter. My health is ok. I am very happy with my residence here. Regards, Leman Avni.** Emine Leman Avni 1935 sent this postcard. (Published by the Albertype Company.)

College Campus, SOUTH HADLEY, Mass.

PORTER HALL AND THE GYMNASIUM, POSTMARKED SEPTEMBER 20, 1911. Inscription on the back: **Am in a house with twelve other freshmen. Mrs. Brunt's off the campus of course. Had one exam today. Easier than I expected. Have a suite of two rooms with two other girls. They haven't come yet. I like everything very much so far. Love Ina.** Ina Luella Paddock 1915 sent this postcard.

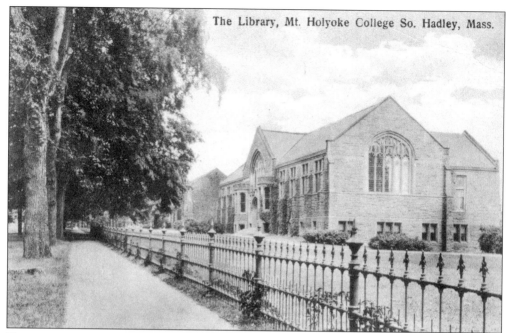

The Library, Mt. Holyoke College So. Hadley, Mass.

THE LIBRARY, POSTMARKED JUNE 9, 1919. Inscription: **Probably I have sent you a picture of this before, but it is a building in which I am very much interested for it was just completed as we entered college. The vines and bushes are so rampant now that the place is greatly improved. Having the time of my short life & so glad I came ... Elsie.** Elsie Brown 1908 was a teacher in New York when she sent this card.

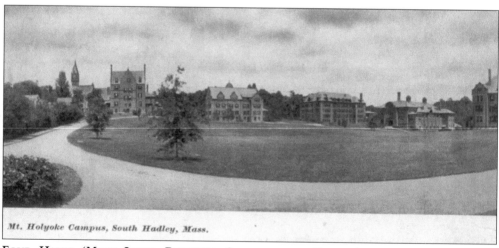

Mt. Holyoke Campus, South Hadley, Mass.

FOUR HALLS (MARY LYON, BRIGHAM, SAFFORD, AND PORTER) AND THE GYMNASIUM, POSTMARKED 1913. Inscription on the back: **Did not see any of those little boys like the one at recess at home. We are having a glorious time and have seen all the home girls. Carolyn.**

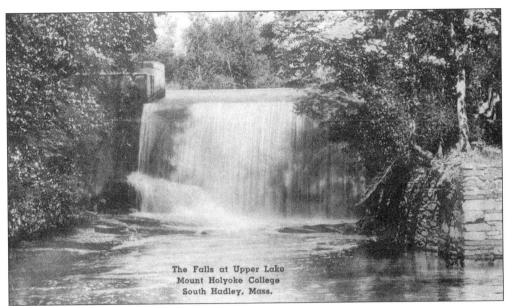

THE FALLS AT UPPER LAKE, POSTMARKED SEPTEMBER 26, 1950. Inscription: **This is only a small part of the view from our room in the new dorm, Lakeside. It's just wonderful to be back at Mt. Holyoke! We keep meeting our friends from last year & meeting new ones too. Classes start on Monday. I hope this will be as wonderful a year as our Freshman yr. was . . . Love to all—Barby.** Lakeside Hall was renamed Torrey Hall in 1956. (Published by Robert A. Glesmann and the Albertype Company.)

THE LILY POND, POSTMARKED OCTOBER 2, 1912. Inscription on the back: **I take it that you were very** *busy* **this summer. It seems good to get back and not be a freshman, although I've been taken for one several times. R.O.N.** Ruby Osborne Norton 1915 was the sender of this postcard.

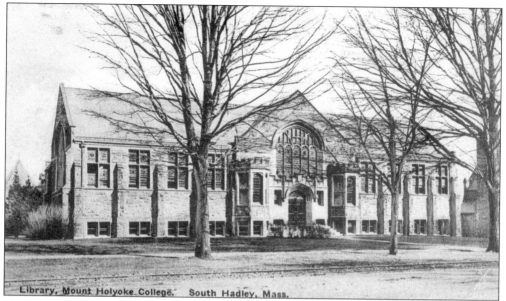

Library, Mount Holyoke College. South Hadley, Mass.

THE LIBRARY, POSTMARKED SEPTEMBER 25, 1921. Inscription: **This is where I shall be spending most of my time from now on as I am taking two reading courses. This is a grand life. Last night the lights in the whole house were off and were just fixed up this afternoon. A few minutes ago my roommate went to connect a desk lamp and blew out a fuse, which means that this side of the house will be in darkness tonight. I miss the Ford like everything. Edna.**

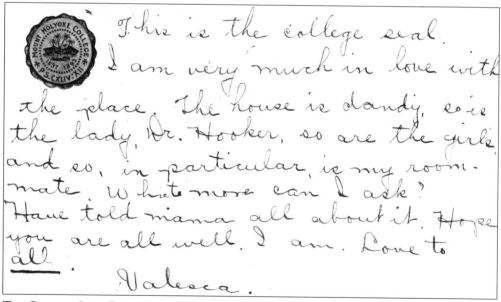

THE COLLEGE SEAL, POSTMARKED SEPTEMBER 24, 1907. Inscription: **This is the college seal. I am very much in love with the place. The house is dandy, so is the lady, Dr. Hooker. So are the girls and so, in particular, is my roommate. What more can I ask? . . . Love to *all*. Valesca.** Valesca Elizabeth Beecher 1911 sent this card. Henrietta Edgecomb Hooker 1873 was a professor of botany at Mount Holyoke.

Three

BUSY DAYS

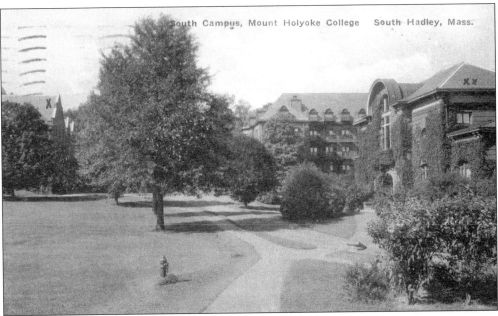

SAFFORD AND PORTER HALLS AND THE GYMNASIUM (SOUTH CAMPUS), POSTMARKED DECEMBER 7, 1934. Inscription: **Thurs. night Dearest Family, Just a card because I'm very busy on source theme, etc. I thought you would like this card. The one cross indicates Brigham, and two crosses, the gym. It shows a part of the south campus, and the road between the bushes and the gym leads to the music building . . . I was glad to get your letters and will try to write a good one Sunday. The report about music for Ch. vacation is favorable. I just love that dictionary. Those dates tasted oh so good and we didn't have any for Thanksgiving. I can't wait till Christmas. Lots of love, Eleanor.** Eleanor Titcomb 1938 graduated with high honors in French and lived in 34–35 Brigham Hall that year, but she got confused and thought Safford Hall was Brigham in this view. Note that Safford is marked with one X, and the gymnasium with two. (Published by Robert A. Glesmann and the Albertype Company.)

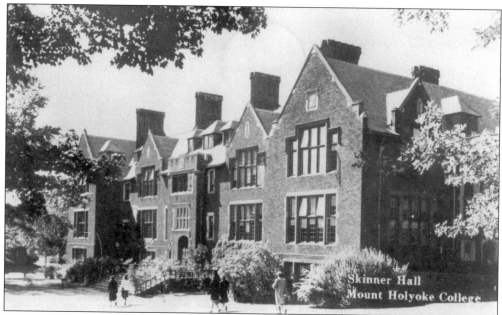

SKINNER HALL, POSTMARKED OCTOBER 11, 1954. Inscription: **Everything is working out wonderfully. I'm rooming with a wonderful girl . . . and we've got a lovely little room in the most beautiful & modern dorm here. The social life is great—I've been out every week so far, classes are very interesting although there's too much homework, & the girls are wonderful . . . Love, Janet.** The sender was Janet J. Lewiston 1958. (Published by $5 Photo Company.)

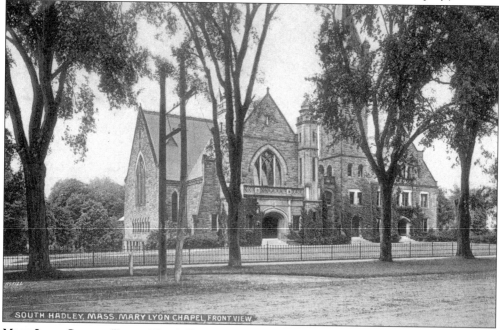

MARY LYON CHAPEL (FRONT VIEW), POSTMARKED SEPTEMBER 23, 1910. Inscription on the back: **We have been pretty busy admiring our new wall paper, adjusting the angles of our pictures, and straightening out the poor freshmen but I will write very soon. With my "bestest" love, M.** Mary Redfield Hull x1913 sent this postcard.

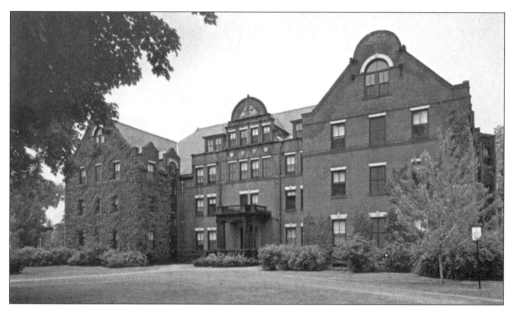

PEARSONS HALL, POSTMARKED FEBRUARY 20, 1981. Inscription: 2/19/81 . . . This semester I'm taking English (a seminar on Southern writers) at Hampshire College, Philosophy, Chinese & Japanese Religion, and Law, Politics & Society at Amherst College. The 5 college valley is a great system so I'm trying to take advantage of it. Last weekend, I went to Dartmouth for their Winter Carnival—it was alot of fun. (Published by Bob Wyer Photo Cards.)

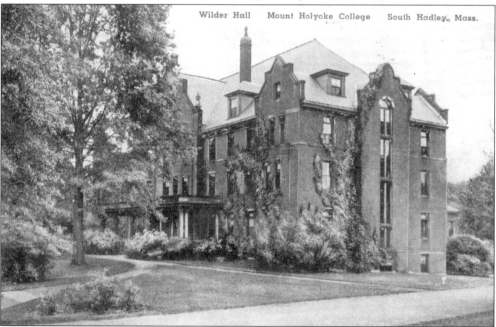

Wilder Hall Mount Holyoke College South Hadley, Mass.

WILDER HALL, POSTMARKED MAY 10, 1943. Inscription: Pvt. Corinne F. Murray . . . Arrived here about 8:30 last night and have been going ever since. Something tells me we're going to be quite busy at all times. May be back in N.Y. week end after next. During World War II, the navy set up a school for communications officers on campus. (Published by Robert A. Glesmann and the Albertype Company.)

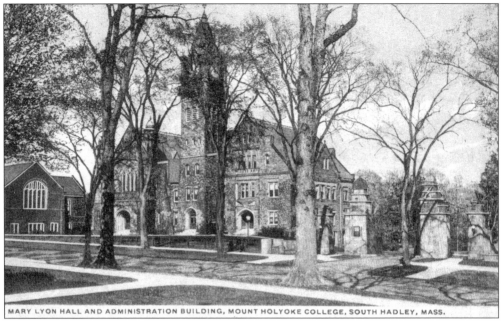

MARY LYON HALL AND ADMINISTRATION BUILDING, MOUNT HOLYOKE COLLEGE, SOUTH HADLEY, MASS.

MARY LYON HALL AND ADMINISTRATION BUILDING, POSTMARKED MAY 11, 1919. Inscription: **Am very busy writing a long paper for English to-morrow, and have a Chem quiz Tuesday . . . I am all right. Shakespeare Romeo and Juliet is the play which is to be given on May Day. Seats are \$.50, \$.75 and \$1.00 . . . Florence says her sister is coming up with five other alumnae . . . Love to all, Arlene.** Arlene E. Preston 1922 sent this postcard.

THE LIBRARY, POSTMARKED SEPTEMBER 24, 1907[?]. Inscription: **Frances feels cheerful over her exam. Mildred not so! Our trunks have come and are all unpacked. Frances has had four classes already and likes them . . . We have Dept meeting this afternoon. I had only ten papers to correct . . . Lots of love to all. Grace.** Grace Elvina Hadley 1904 was a Latin instructor at Mount Holyoke when she sent this postcard.

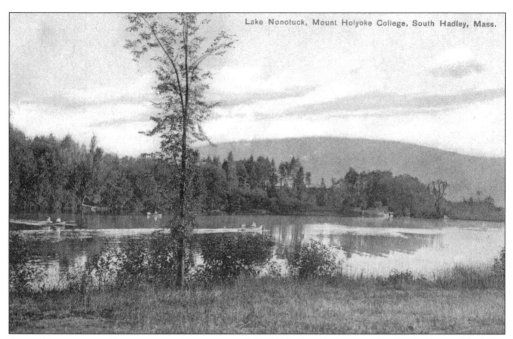

LAKE NONOTUCK, POSTMARKED SEPTEMBER 25, 1908. Inscription on the back: **Sept. 24, 1908. College opened this morning with about [260?] girls in the freshman class. I am glad to begin work again. we are busy although the girls do not begin their laboratory work for a week. We are having hot [cloudy?] weather. With love. Sarah.**

AUSTRALIAN BALLOT POST CARD

MOUNT HOLYOKE COLLEGE

South Hadley, Mass., *May 4* 190 *8*

THE ITEMS MARKED WITH AN X EXPRESS MY SENTIMENTS AND TELL THE NEWS

X	Arrived here safely		Got a flunk note to-day		Had a slow time to-day
	Arrived late, have condition		Got EE in a quiz to-day		House Chairman squelched me
X	My money is all gone		Am working on my Lit paper		Basket ball is going splendidly
	Am awfully hungry	X	Took a sit up last night		Our team is champion
	Shut out from breakfast this A.M.		Took a get up this morning		Went to Amherst dance last night
X	Had a spread last night		Went to sleep in class to-day		My third prom man has stung me
	Dinner at Art Nook yesterday	X	Have writers cramp taking notes		My prom man sprained his thumb
X	Made fudge this afternoon		My fountain pen is lost		My crush smiled at me to day
X	Am terribly rushed		I forgot my "dom" work again		My crushee took me riding to-day
	Am plugging for a quiz	X	This is a refin(e)ing place	X	Am glad to know you are well
	Have 23 appointments to-day		Bills are rushing in this week	X	Don't worry about me
	Three required lectures this week		Please send my allowance soon		Am expecting check any time
X	Bluffed six recitations to-day		Had my hair laundered to-day	X	Very sincerely yours
	Got student lecture in Zoo		Had pictures taken this week		Your affectionate cousin
	Didn't get student lecture in Zoo		Made up six gym *rude* cuts to-day		Your loving daughter
	Cut Psyche to go walking	X	Just been on a *ride* to Springfield		As ever, your sister
	Got A in a quiz to-day	X	Had a slick time to-day		Signed *Mae Belle*

AUSTRALIAN BALLOT, POSTMARKED MAY 4, 1908. Inscription: **Just been on a ride to Springfield . . . Mae Belle.** The writer selected 15 of the 50 categories under "Items marked with an X express my sentiments and tell the news," added the above inscription to one, and partially blocked the category that reads "Made up six gym cuts to-day."

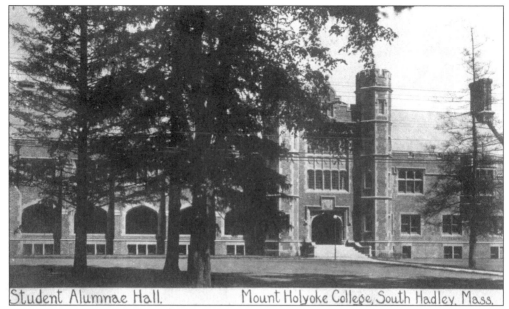

Student Alumnae Hall. Mount Holyoke College, South Hadley, Mass.

STUDENT ALUMNAE HALL, POSTMARK UNDATED. Inscription: **This evening along with my other little jobs I had a rather long meeting of the Editors of Pegasus. It was boring and I was glad when it ended. My leg is** *much* **better today and in fact I feel quite spry. I danced with Mead's trickiest dancer tonight and it went fine—still a bit stiff but otherwise O.K.! . . . Always, Alice.** Alice Coulter McLean 1926 wrote this card. Her mother was Bertha Coulter 1897.

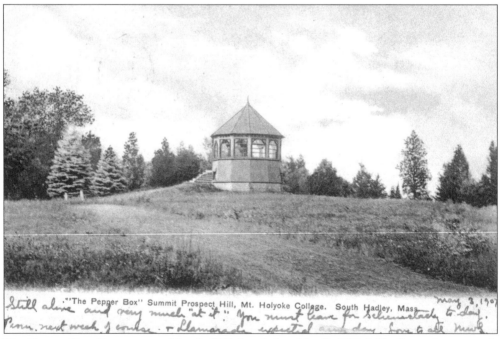

Still alive and very much "at it." You must leave for Schenectady to-day. Prom. next week of course. + Llamarada expected any day. Love to all. *may 3, 1907*

."The Pepper Box" Summit Prospect Hill, Mt. Holyoke College. South Hadley, Mass.

THE PEPPER BOX, POSTMARKED MAY 3, 1907. Inscription: **May 3, 1907. Still alive and very much "at it." You must leave for Schenectady today. Prom. next week, of course; & Llamarada expected any day. Love to all, M.W.S.** Mary Warren Shepard 1908 served as a missionary in China after she graduated.

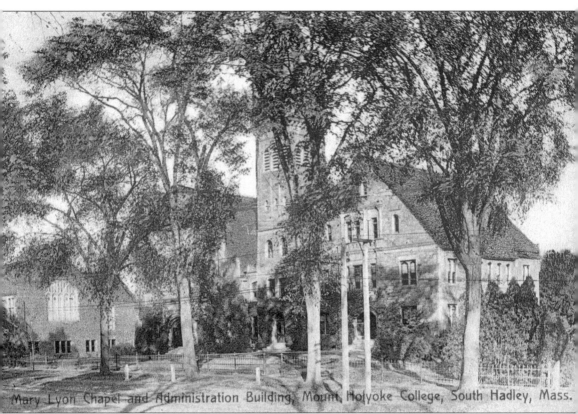

Mary Lyon Chapel and Administration Building, Mount Holyoke College, South Hadley, Mass.

MARY LYON CHAPEL AND ADMINISTRATION BUILDING, POSTMARKED FEBRUARY 19, 1910. Inscription: **Dear mama, This morning Sat. I received a letter from you, but evidently it was there Fri night. But as I was at gym. then and right after dinner had to go to the senior play I didn't get much studying or anything else done. The play was too cute for any thing. Some parts of it had knocks on the faculty, and some of the girls represented dolls, teddy bears, etc. . . . It was about 10.40 and of course I wasn't in bed until after 11, and as I had English Latin & Math with no study periods, I had to get up at 5 this morning. . . . a few things have been going on though. Prayer meeting, Miss W. reception Thurs & then gym and play Friday . . . It is quite pleasant up here . . . Don't worry any more mama for I guess we're all right now. I am any way. Love and oooo Flossie.** This card was sent by Florence Parker Davoll x1913.

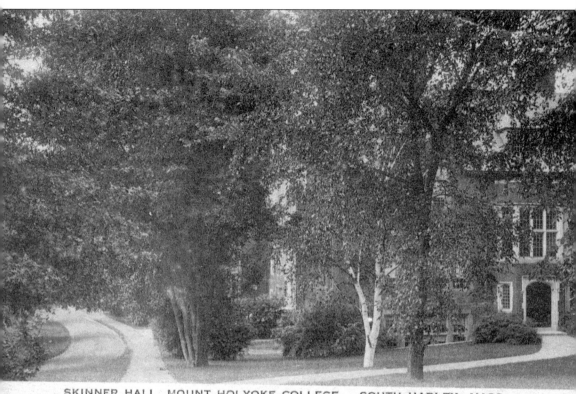

SKINNER HALL, MOUNT HOLYOKE COLLEGE. SOUTH HADLEY, MASS.

Skinner Hall, Postmarked November 4, 1922. Inscription: **This week I have been especially busy. There have been lectures almost every night which we were supposed to attend . . . Last Mon. morning I got up at six o'clock and went for a walk before breakfast. Just think of it! We had been speaking about how some people can wake themselves up at any hour they want, so I decided to try the experiment. It really worked. When I looked at my watch it was just 5 min. after 6. I am convinced that I began the process of waking up at exactly 6 o'clock. You have written to me so often that I really don't see how I can answer *all* your letters. But don't stop writing all together. Ethel.**

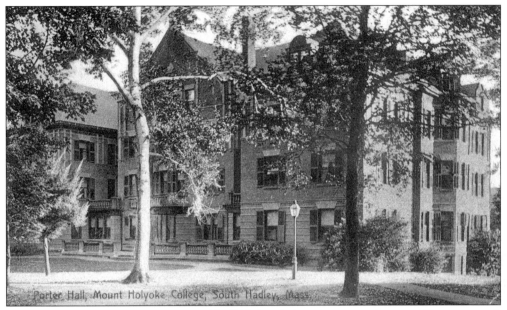

PORTER HALL, POSTMARKED JANUARY 28, 1910. Inscription: **One exam is over. Was very good. Yesterday went . . . to a tea at Miss Young's room (astronomy teacher) . . . Tomorrow will begin studying for German . . . I s'pose you have heard about the new comet . . . I saw a little of the tail last night . . . Lots of love to all—Louise.** Louise Freeland Jenkins 1911 was an instructor of astronomy at Mount Holyoke after she graduated. It was Halley's comet that she saw.

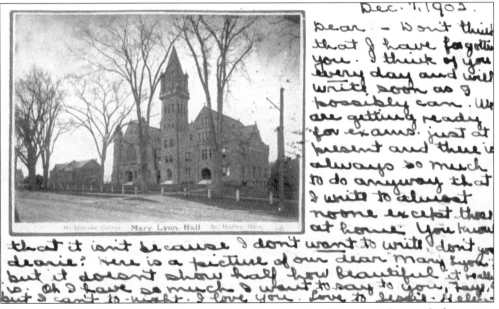

MARY LYON HALL, POSTMARKED DECEMBER 8, 1902. Inscription: **We are getting ready for exams. just at present and there is always so much to do anyway that I write to almost noone . . . You know that it isn't because I don't *want* to write, don't you dearie? Here is a picture of our dear "Mary Lyon," but it doesn't show half how beautiful it really is . . . I love you. Helen.**

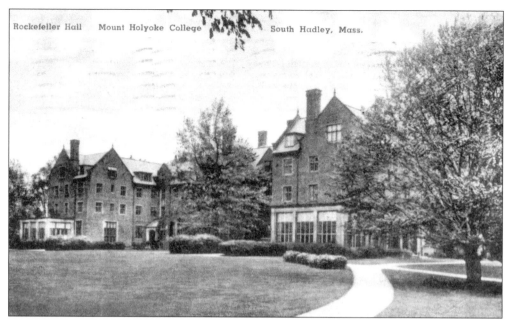

ROCKEFELLER HALL, POSTMARKED JULY 8, 1943. Inscription: **Nav. Res. Midshipmen's School . . . This is a hectic and *busy* life. Hope I live through it. Ordered uniforms today. Note change of address. I'm delighted to be here instead of at Smith. Edna.** During World War II, the navy set up a school for communications officers on campus, and Rockefeller Hall was the dormitory in which they roomed. The postcard was mailed for free. (Published by Robert A. Glesmann and the Albertype Company.)

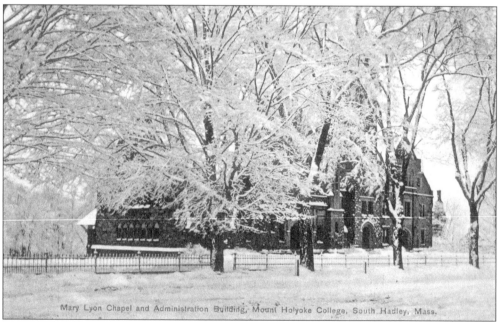

MARY LYON CHAPEL AND ADMINISTRATION BUILDING, POSTMARKED DECEMBER 19, 1908. Inscription on the back: **This is a very late apology for keeping your prose book so long . . . I have at last passed off that Latin Prose This is a great place but my! we have to study hard. I hope you will have a very merry Mas. Edna Sammis.** Edna Allen Sammis 1912 sent this postcard.

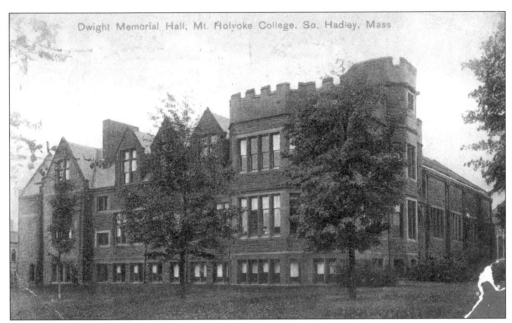

DWIGHT MEMORIAL HALL, POSTMARKED MAY 31, 1907. Inscription on the back: **We are all well and working hard; will write when the rush is over a little. Paint & plant, wash and iron, cook and eat, sew and sleep, takes up most of the time. Love, [signature].**

THE JUDSON, POSTMARKED SEPTEMBER 29, 1922. Inscription: **My room is . . . where the cross is . . . Tonight I ironed my curtains. Tomorrow after I clean my rods, I hope to get the curtains up. I'm busy every minute but am certainly enjoying it immensely. It's after 10:30 & I've been going since 6:30 this morn . . . Lovingly Marjorie.** Marjorie Eleanor Smith 1922 lived in 18 Judson that year. Note the cross mark on the third floor.

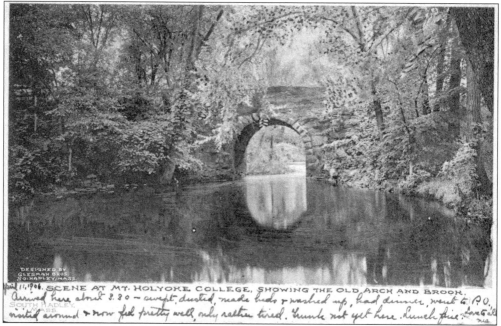

THE OLD ARCH AND BROOK, POSTMARKED APRIL 12, 1906. Inscription on the front: **April 11, 1906. Arrived here about 3.30—swept, dusted, made beds & washed up, had dinner, went to P.O., visited around & now feel pretty well, only rather tired. Trunk not yet here. Lunch fine. Love to all, May.** Mary Warren Shepard 1908 served as a missionary in China after she graduated.

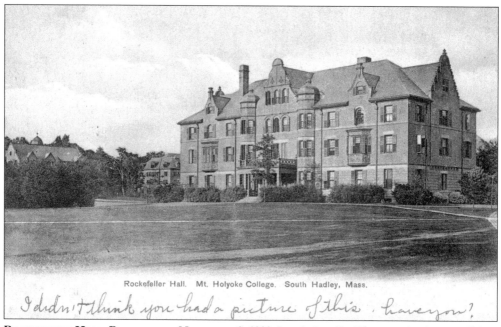

Rockefeller Hall. Mt. Holyoke College. South Hadley, Mass.

ROCKEFELLER HALL, POSTMARKED NOVEMBER 3, 1909. Inscription: **Sat I have recitations until 2.55 but Mon. I have only 3. I am afraid that I would be in classes when you come. I will try not to have most studying when you come. Now tonight . . . I have to go to Junior Reception. Am going to wear pink dress . . . ooo love Florence.** This card was sent by Florence Parker Davoll x1913.

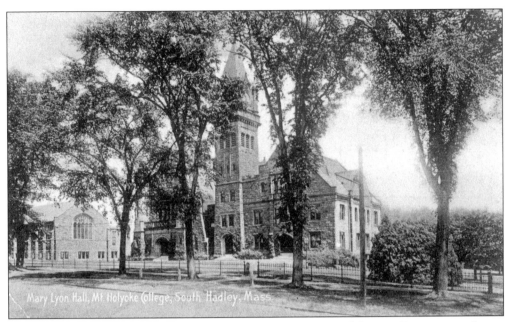

MARY LYON HALL, POSTMARKED SEPTEMBER 26, 1908. Inscription: **Of course I want your picture & should have said so sooner, but your card came when I was making final preparations for College. You will understand what a busy time that is . . . I have a large pleasant room, a good roommate, and friends near by, so that I anticipate a splendid year . . . Yours—"Johnny."**

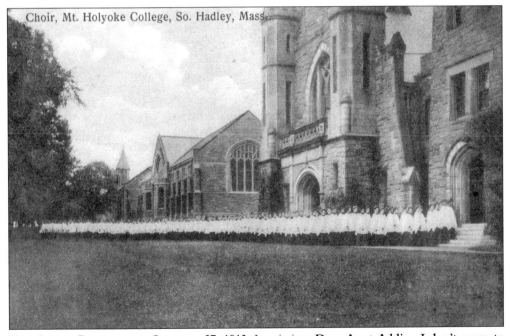

THE CHOIR, POSTMARKED OCTOBER 27, 1913. Inscription: **Dear Aunt Addie—I don't seem to have time to write many letters, so write cards mostly. It is just pouring rain today. I don't like so much wet weather. I am getting over my homesickness and think I will be alright now. Have to work very hard . . . Love Miriam.** Miriam Ely 1917 sent this postcard.

ABBEY CHAPEL, UNPOSTMARKED. Inscription: **Hi Renalde! Sorry I didn't write sooner. Had a terrific time today—went to Outing Club 4 mi. from here for supper, climbed Mt. Holyoke. I am going to a mixer with Amherst College tomorrow—living in South Mandelle Hall. Love, Alice. P.S. Write when you get a chance.** (Published by Artvue Post Card Company.)

Four
TOO MUCH WORK!

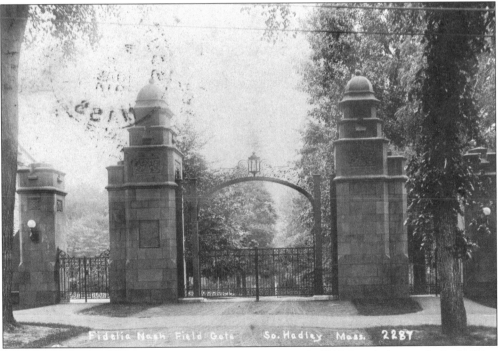

THE FIDELIA NASH FIELD GATE, POSTMARKED FEBRUARY 9, 1914. Inscription on the back: **Poor lady, I'm so sorry you're so miserable. Please get better quickly. Wish you were up here in this lovely, lovely country; then you'd *have* to get well so's to enjoy it all. This is our new gateway of which we're so proud. Exams are over and I didn't flunk any. Don't be ashamed of me tho' when you hear my marks this year. I really have tried. Much love, Madeleine. Please give my love to Miss Nell and Uncle George.** Madeleine Wayne 1915 graduated Phi Beta Kappa, so her grades must not have been too bad.

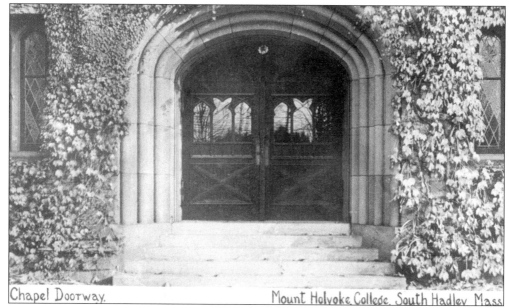

Chapel Doorway. Mount Holyoke College, South Hadley, Mass.

THE CHAPEL DOORWAY, POSTMARKED NOVEMBER 17, 1921. Inscription on the back: **I am enjoying myself greatly here. Our days are very full, just at present with many quizzes. I wish I was to be in Medford for Thanksgiving, too. Sincerely, Hilda.**

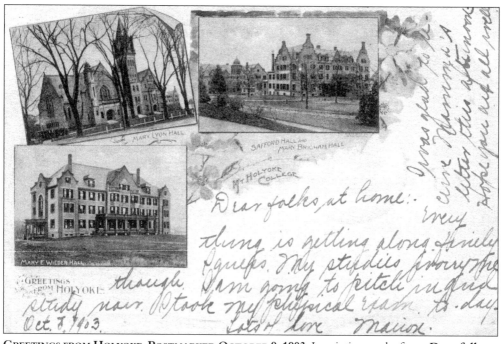

GREETINGS FROM HOLYOKE, POSTMARKED OCTOBER 9, 1903. Inscription on the front: **Dear folks at home: Every thing is getting along finely I guess. My studies worry me though. I am going to pitch in and study now. I took my physical exam to-day. Lots of love Marion. Oct 8, 1903. I was glad to receive Mamma's letter this afternoon—Hope you are all well.** Marion Rood Pratt 1909 sent this postcard. Her mother and two sisters also attended Mount Holyoke.

Lake Nonotuck, Mount Holyoke College, South Hadley, Mass.

for a student lecture. Horrible! R.F.B.

LAKE NONOTUCK, POSTMARKED DECEMBER 1, 1909. Inscription: **Don't you think I can dance as many dances as any girl? The girls here say I cannot. I say I can—you seem doubtful one way or other, so I will leave it for you to decide. It would be fun to dance them all . . . You should see me grinding away for a student lecture. Horrible! R.F.B.** Ruth Frances Bushnell 1912 wrote this postcard to her future husband. They had a daughter who attended Mount Holyoke.

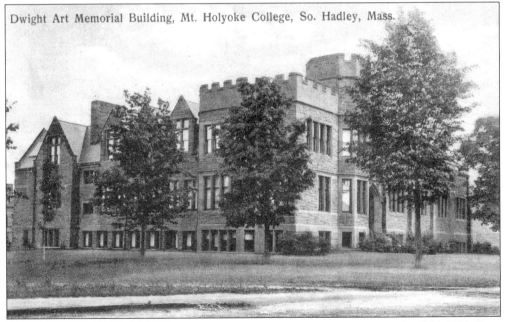

Dwight Art Memorial Building, Mt. Holyoke College, So. Hadley, Mass.

DWIGHT ART MEMORIAL BUILDING, POSTMARKED APRIL 26, 1916. Inscription: **April 26, 1916. Dear Alice, It was so nice of you to remember me while I was in the hospital and to come in when I got home. I am glad to be back at college but of course have loads to do. Yours always Esther B.** Esther Marion Brackett 1917 sent this postcard.

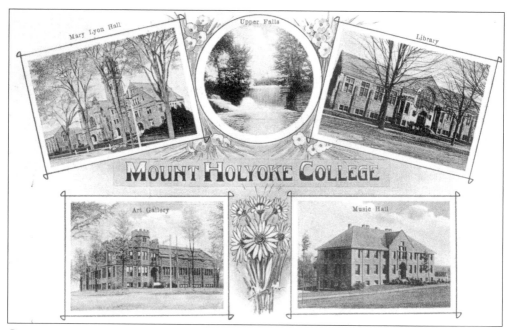

GREETINGS FROM MOUNT HOLYOKE, POSTMARKED NOVEMBER 16, 1912. Inscription on the back: **It's 2:30, and I have an afternoon of work ahead on the D. J. paper, due at 6 to-morrow. Had Chem quiz this A. M. and discovered that Chem average much higher than I expected. Your letter and C's came last night . . . I shall have three days at home . . . A.A.R.** Alice Augusta Rogers 1912 received her degree in 1914.

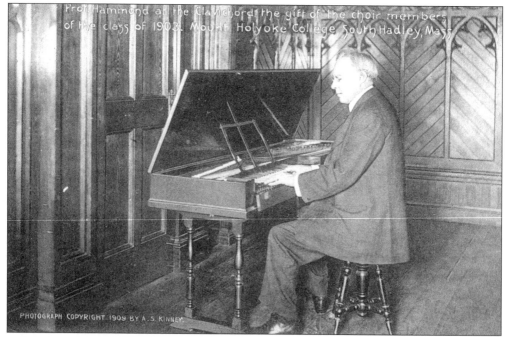

PROFESSOR HAMMOND AT THE CLAVICHORD, POSTMARK ILLEGIBLE. Inscription on the back: **I never worked so hard in my life before. College means hard work in sections. Just now we hardly have time to eat, for "quizzes" are ever present. Alice.**

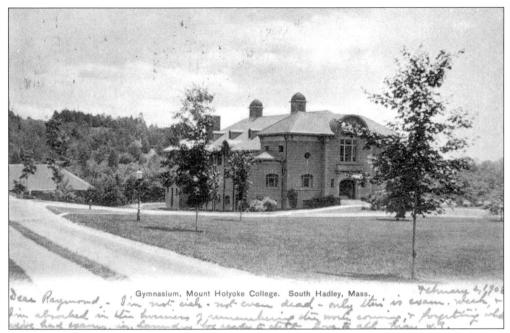

Gymnasium, Mount Holyoke College. South Hadley, Mass.

Dear Raymond, — I'm not sick - not even dead - only this is exam. week, & I'm absorbed in the business of remembering the work coming, & forgetting what we've had exams. in.

THE GYMNASIUM, POSTMARKED FEBRUARY 3, 1906. Inscription: **I'm not sick—not even dead— only this is exam. week, & I'm absorbed in the business of remembering the work coming, & forgetting what we've had exams. in. Laundry box ready to start. Love to all, May W.S.** Mary Warren Shepard 1908 served as a missionary in China after graduation.

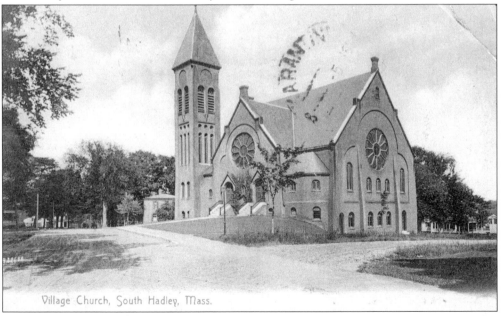

Village Church, South Hadley, Mass.

THE VILLAGE CHURCH, POSTMARKED APRIL 26, 1935. Translated Turkish inscription: **I am starting to work very hard again for finals. On the 25th May the lectures will finish and the day after the examinations will start. I am very busy like the others. On the 10th Jun there will be finishing ceremonies here. I wish you were all here, because everyone's family will be here.** Emine Leman Avni 1935 lived in Turkey after graduation. (Published by Edgar T. Scott.)

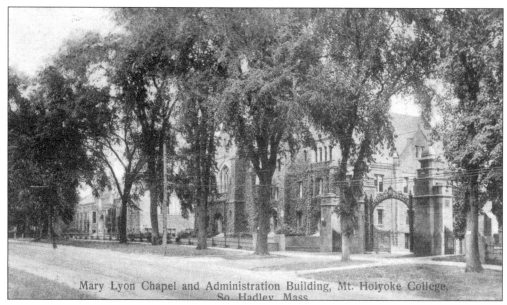

Mary Lyon Chapel and Administration Building, Mt. Holyoke College,
So. Hadley, Mass.

MARY LYON CHAPEL AND ADMINISTRATION BUILDING, POSTMARKED OCTOBER 15, 1915.
Inscription: **Dearest Margaret, Did you think I had forgotten you, and have you me? I look at you often in the picture over our fireplace . . . College is awful hard. I study all the time so does Helen. We room together! Love, write soom [sic] Gwendoline.** Helen V. Ovans 1919 was from Allston, Massachusetts, and Gwendoline Keiver x1919 was from neighboring Brighton. They lived at Mr. Bradford's that year.

MANDELLE HALL, POSTMARKED SEPTEMBER 1, 1942. Inscription: **What a lovely place! Our classes are held under the trees. Every word is in French except a highlight here and there contributed by a Harvard or Yale Government Professor . . . Best wishes. With love. Moxie.** (Published by the Albertype Company.)

50

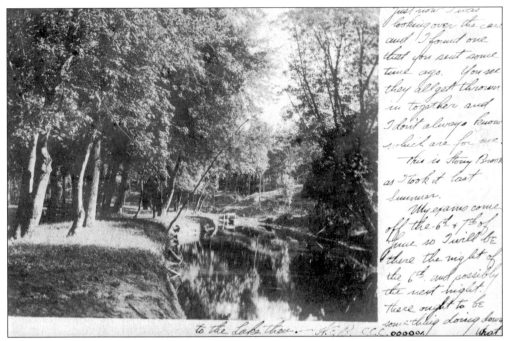

The handwritten note on the postcard reads: *Just now I was looking over the card and I found one that you sent some time ago. You see they all get thrown in together and I don't always know which are for me. this is Stony Brook as I took it last summer. My exams come off the 6th & 7th of June so I will be there the night of the 6th and possibly the next night. there ought to be something doing down to the Lake then. H.E.B. CCC 000001 What*

STONY BROOK, POSTMARKED APRIL 24, 1904. Inscription: **This is Stony Brook as I took it last summer. My exams came off the 6th & 7th of June so I will be there the night of the 6th and possibly the next night. There ought to be something doing down to the Lake then. H.E.B.** Harriet Elizabeth Ball 1904 had a step granddaughter who attended Mount Holyoke, Barbara Cowan Bryer 1935.

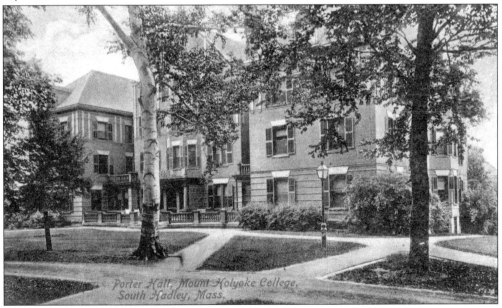

Porter Hall, Mount Holyoke College,
South Hadley, Mass.

PORTER HALL, POSTMARK BLURRED. Inscription on the back: **I hope that you are enjoying Tufts as much as I am Mt. Holyoke this year. Studying is awfully hard this year but I like all my work and that counts a great deal. This is my dormitory. Sincerely Helen Stearns.** Helen Rachel Stearns 1917 lived in Porter during her sophomore and senior years.

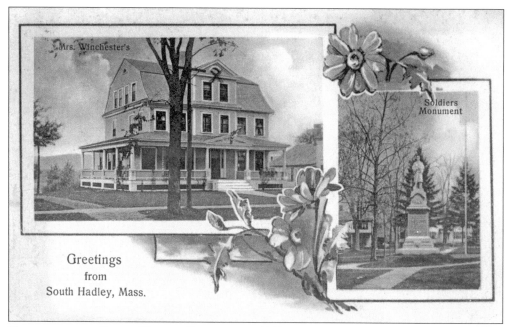

GREETINGS FROM SOUTH HADLEY, POSTMARKED 1913. Inscription: **Dear Mama—Just rec'd your letter. I planned to write last night but am very busy this week as always . . . I have just been to German, I hate the stuff. It is my hardest course. The cross indicates our room. Much love, Miriam.** Miriam Louise Dow x1917 lived at Mrs. Winchester's that year.

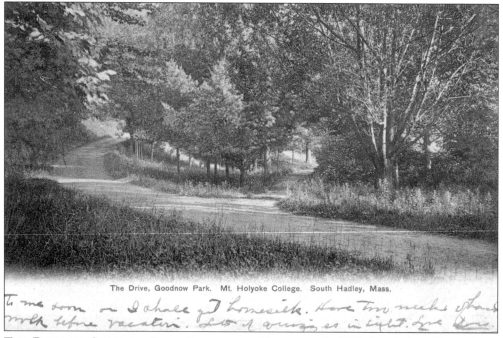

THE DRIVE AT GOODNOW PARK, POSTMARKED DECEMBER 6, 1909. Inscription: **Dear Folks: Haven't news enough to write a letter I don't believe . . . Hurry up & write to me soon or I shall get homesick. Have two weeks of hard work before vacation. Lots of quizzes in sight. Love Lois.** Lois Wilson Woodford 1913 sent this postcard.

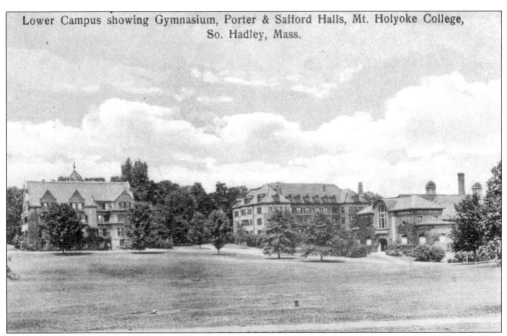

LOWER CAMPUS (THE GYMNASIUM AND PORTER AND SAFFORD HALLS), POSTMARKED SEPTEMBER 20, 1915. Inscription on the back: **It is Monday morning & we have the lovely prospect of an exam. this afternoon. Am having a lovely time. Am awfully sorry we couldn't come up & see you last Monday before you left . . . Marjorie.**

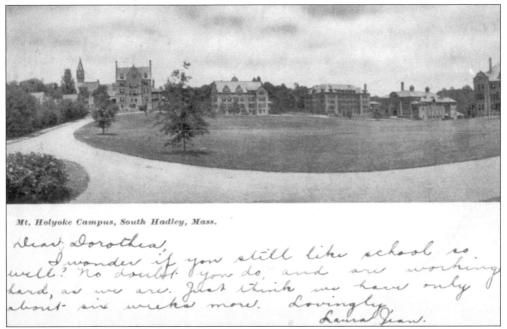

MOUNT HOLYOKE CAMPUS, POSTMARKED APRIL 29, 1912. Inscription on the front: **Dear Dorothea, I wonder if you still like school so well? No doubt you do, and are working hard, as we are. Just think we have only about six weeks more. Lovingly, Laura Jean.** Laura Jean Jarrett 1915 wrote this postcard.

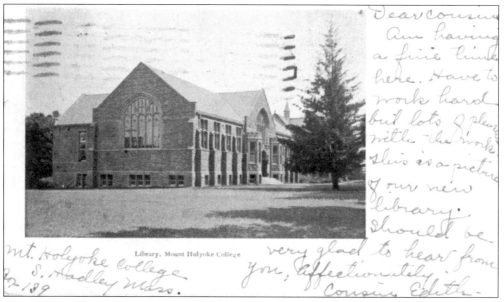

Library, Mount Holyoke College

Mt. Holyoke College
S. Hadley Mass.
189

Dear cousins Am having a fine time here. Have to work hard but lots of pleasure with the work. This is a picture of our new library. Should be very glad to hear from you, Affectionately Cousin Edith—

THE LIBRARY, POSTMARKED OCTOBER 11, 1905. Inscription on the front: **Dear cousins, Am having a fine time here. Have to work hard but lots of pleasure with the work. This is a picture of our new library. Should be very glad to hear from you, Affectionately, Cousin Edith.**

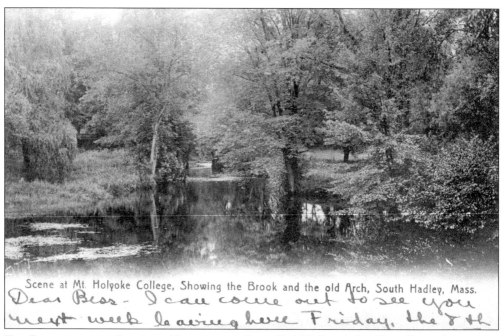

Scene at Mt. Holyoke College, Showing the Brook and the old Arch, South Hadley, Mass.

Dear Bess - I can come out to see you next week leaving here Friday, the 8th

THE BROOK AND THE OLD ARCH, POSTMARKED APRIL 28, 1910. Inscription: **Dear Bess—I can come out to see you next week leaving here Friday, the** *8th* **. . . If it is alright let me know soon, can you? You see I'm cutting classes to come & can arrange to come then O.K. I think. Love, Emma.**

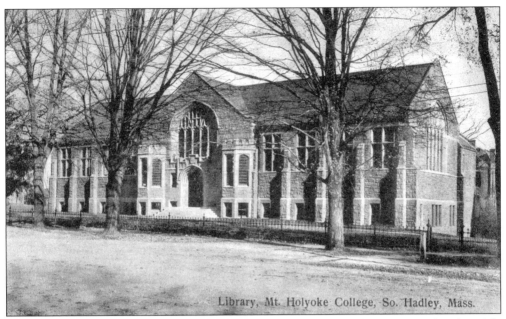

Library, Mt. Holyoke College, So. Hadley, Mass.

THE LIBRARY, POSTMARKED SEPTEMBER 28, 1914. Inscription on the back: **I went to Chemistry lab. this morning prepared for three hours work only to find that lab won't be mine till next Monday . . . I wish you could see my theme. It is a beauty . . . I am going to play tennis perhaps if I can get anybody who is not busy. Love Annetta.** Annetta Rebecca Masland 1918 wrote this postcard.

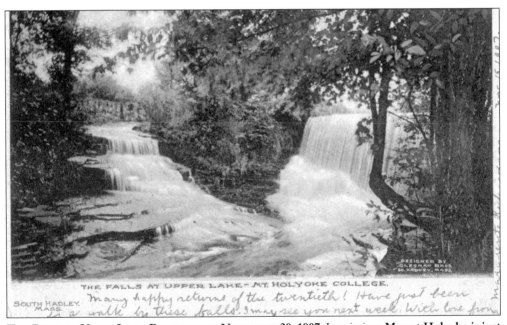

THE FALLS AT UPPER LAKE – MT. HOLYOKE COLLEGE.

SOUTH HADLEY. MASS. Many happy returns of the twentieth! Have just been for a walk by these falls. I may see you next week. With love from

THE FALLS AT UPPER LAKE, POSTMARKED NOVEMBER 20, 1907. Inscription: **Mount Holyoke is just great. I enjoy it ever so much, but I have to work very hard. . . . I am at an off-campus house where we have very good times. There are ten girls here. I find letter writing is out of the question . . . M. R.** Marguerite Richardson 1911 lived at Mr. Lovell's during the 1907–1908 school year.

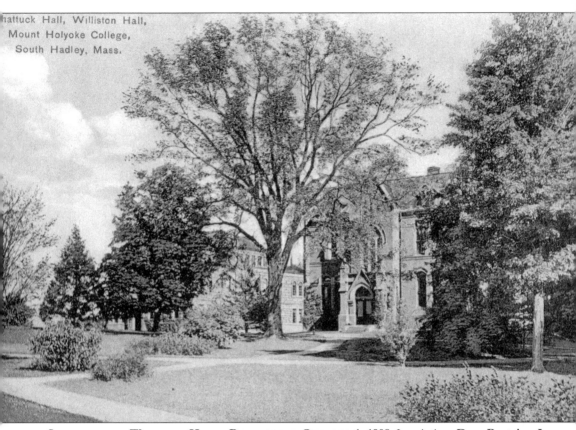

hattuck Hall, Williston Hall,
Mount Holyoke College,
South Hadley, Mass.

SHATTUCK AND WILLISTON HALLS, POSTMARKED OCTOBER 1, 1908. Inscription: **Dear Beatrice, I was awfully sorry that I didn't get a chance to come over & say good-bye to you, but the last two days were so full that I didn't get a minute. It is great up here and the girls are splendid. Am just down the hall from Dorothy Gamsby. We are in Pres. Woolley's Hall. The older girls gave us Freshies a Welcome Party to the hall. It was lots of fun. There is something doing in the way of fun every Tuesday night. Gracious but we have to study hard. Edna.** Edna Allen Sammis 1912 worked for the YWCA during World War I. Dorothy Burwell Gamsby 1912 worked for the Red Cross in Serbia during World War I. Both from Bridgeport, Connecticut, they lived two doors away from each other in Brigham Hall. Pres. Mary Woolley lived in the head resident's apartment on the first floor of Brigham.

Five
CAMPUS EVENTS

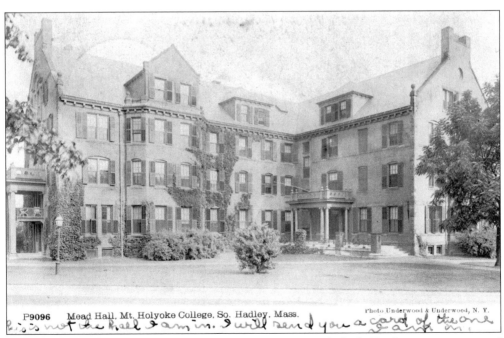

P9096 Mead Hall, Mt. Holyoke College, So. Hadley, Mass. Photo Underwood & Underwood, N. Y.

MEAD HALL, POSTMARKED DECEMBER 15, 1915. Inscription on the back: **To-day we are separated from the rest of the world. There has been no street cars running out here or no mail has come and the telephone wires are down. We might just as well be in Europe. Love Corinne.**

POSTMARKED FEBRUARY 15, 1910. Inscription: **Miss N. went peacefully away about 10 last eve. There had been apparently little change for a long time . . . but yest. she failed rapidly & Dr. said she would not probably live through the night . . . The body was taken down to Holyoke undertaker's rooms this p.m. arrayed in dress we selected this noon . . . Miss N.'s condition has been so distressing & so hopeless that we can only be grateful for her release from her body. There was no return of consciousness, but she was quiet all day yest.—moans all ceased.— Everett House still over full of tonsilitis patients, & many in Pearsons—17 yesterday & more in Mead. Nurse in each house. No one alarmingly ill . . . Yours. E. P. Bowers.** The woman who died was Mary Olivia Nutting 1852, Mount Holyoke's first librarian. The sender of this card was Ellen Priscilla Bowers 1858, teacher of English literature at Mount Holyoke. The recipient of the card was Julia Elizabeth Ward 1857, former teacher and principal at Mount Holyoke. At that time, Everett House served as the infirmary.

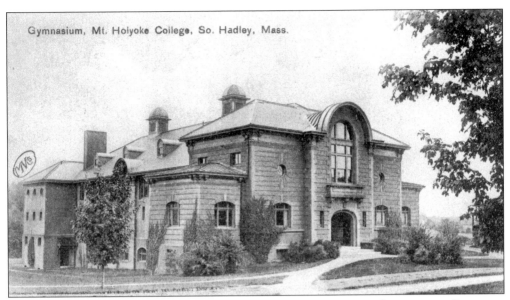

Gymnasium, Mt. Holyoke College, So. Hadley, Mass.

THE GYMNASIUM, POSTMARKED NOVEMBER 9, 1908. Inscription: **You are by no means forgotten. We certainly miss the Seniors—and think of you often. Did you know that Marjory Cobb isn't back on account of her health. She is better and I think it was wise for her not to come back this year . . . With love, Ruth Seaver.** The recipient of this card was Mabel Harriet Pratt 1908. Marjory Ross Cobb x1910 died in 1913. The author of the card was Ruth Buchanan Seaver 1911.

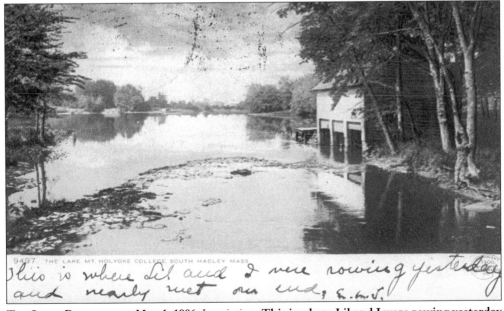

THE LAKE, POSTMARKED MAY 1, 1906. Inscription: **This is where Lil and I were rowing yesterday and nearly met our end. E.L.J.** The woman who rowed with the sender was Lillian S. Maclay 1906, whose grandmother Henrietta Caroline Sperry x1847 was a missionary in China and Japan.

CAMPUS VIEW, POSTMARKED JULY 22, 1917. Inscription: **The black walnut has gone! Blown down in a terrific shower yesterday. We feel as if somebody had died . . . Dr. Clapp is at Woods Hole and they say she is *perfectly* well again. Love—A.H.T.** The author was Abby Howe Turner 1896, a physiology professor. Cornelia Maria Clapp 1871 was a zoology professor. The postcard was addressed to Nellie Houston Swift 1896. Senior rope skipping traditionally took place around this black walnut, the large tree in the center of this image.

THE DRIVE AT GOODNOW PARK, POSTMARKED OCTOBER 3, 1912. Inscription: **Wish you might have seen the pageant. It was wonderful . . . E.V.C.** Effie Victoria Clubb 1915 sent this postcard. The pageant she mentioned was the 75th anniversary celebration at the college.

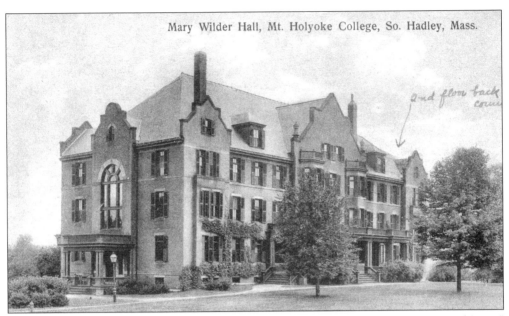

Mary Wilder Hall, Mt. Holyoke College, So. Hadley, Mass.

2nd floor back corner

MARY WILDER HALL, POSTMARKED OCTOBER 2, 1918. Inscription: **I am all right, quite "chipper" in fact. Stella feels quite a little better. She didn't have the influenza, just a severe cold. I hope that the epidemic is no worse at home, and that it has touched none of you. It is better here . . . With love to all, Dorothy.** The author of the card was Dorothy Horne Albee 1919. Her roommate in 23 Wilder that year was Stella M. Davis 1919.

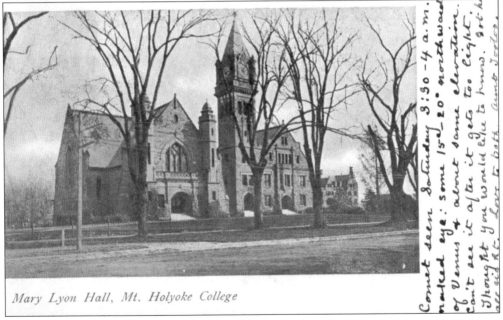

Mary Lyon Hall, Mt. Holyoke College

Comet seen Saturday 3:30–4 a.m. naked eye: some 15–20° northward of Venus + about same elevation. Can't see it after it gets too light. Thought you would like to know. Got both. Love to both. Aunt Tootoo

MARY LYON HALL, POSTMARKED APRIL 25, 1910. Inscription: **Comet seen Saturday 3:30–4 a.m. naked eye: some 15–20 degrees northward of Venus and about same elevation. Can't see it after it gets too light. Thought you would like to know . . . Love to both. Aunt Tootoo.** The message refers to Halley's comet.

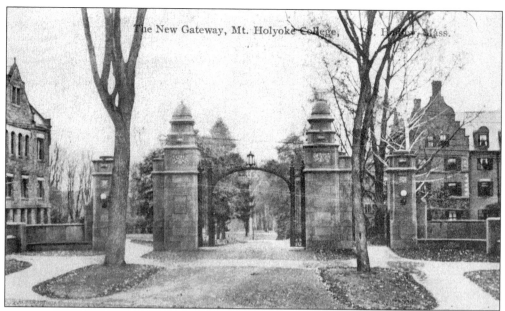

THE NEW GATEWAY, POSTMARKED MAY 20, 1913. Inscription: **Dear Kate, I was at Mt. Holyoke for the pageant rehearsal . . . I saw Miss Bowers and we talked of you and I wished I had asked her of the "Rhubarb pie episode." Margaret McGill.** The author was Margaret McGill 1894. Ellen Priscilla Bowers 1858 was an English literature teacher at Mount Holyoke. The card was addressed to Kate Hayden Pattangall 1889.

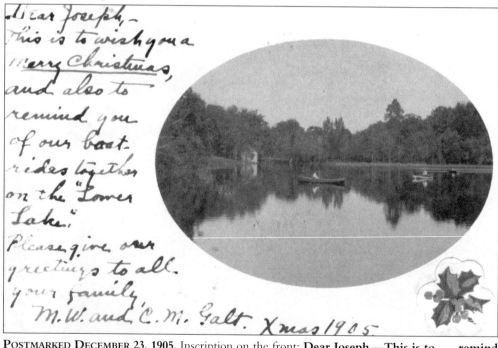

POSTMARKED DECEMBER 23, 1905. Inscription on the front: **Dear Joseph,—This is to . . . remind you of our boat-rides together on the "Lower Lake." . . . M.W. and C.M. Galt. Xmas 1905.** The authors were Mary Wallace Galt 1908, who became an instructor of mathematics at Mount Holyoke a few years later, and her sister Caroline M. Galt, professor of archaeology and Greek at Mount Holyoke.

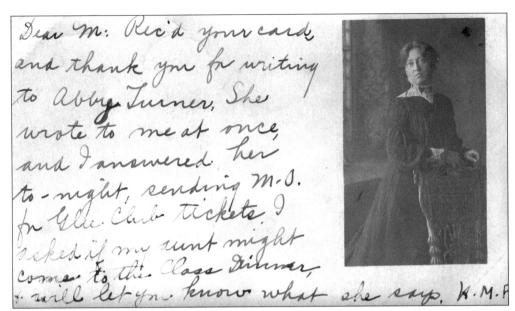

A PHOTO PORTRAIT, UNPOSTMARKED. Inscription: **Thank you for writing to Abby Turner. She wrote to me at once, and I answered her to-night, sending M.O. for Glee Club tickets. I asked if my aunt might come to the Class Dinner . . . H.M.F.** The card is addressed to Martha Day Byington 1896 at an address where she lived in 1905. The author was Henrietta Mary Franchois x1896. Abby Howe Turner 1896 was a physiology professor at Mount Holyoke.

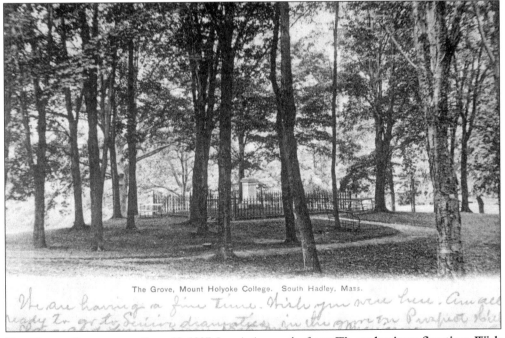

THE GROVE, POSTMARKED JUNE 18, 1907. Inscription on the front: **We are having a fine time. Wish you were here. Am all ready to go to Senior dramatics in the grove on Prospect Hill. Clara and Louise room with me. Marian.** Students lived in triples even back then.

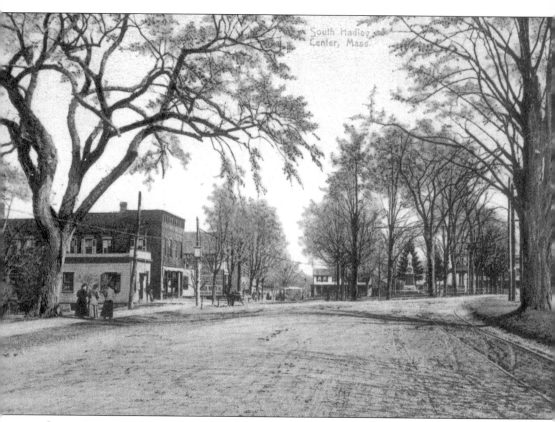

SOUTH HADLEY CENTER, POSTMARKED NOVEMBER 1, 1912. Inscription: **You doubtless remember this place. You just ought to see the changes here, new houses, old ones moved, etc. and the new gate is a great improvement. Probably you have heard about "the 75th" Now the excitement is the campaign. Had a political meeting with speeches last night and a parade Tues. night. And we are going to vote next Tues . . . Lydia.** The reference to "the 75th" was the 75th anniversary celebration of the founding of Mount Holyoke. During election seasons before suffrage, the students held mock campaigns and elections on campus. This postcard was addressed to Edith Isabel Woodruff x1915, who did canteen work in France during World War I.

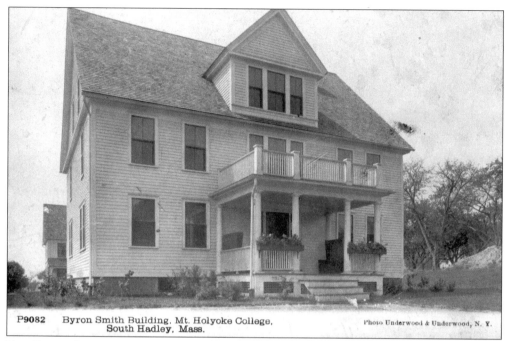

P9082 Byron Smith Building, Mt. Holyoke College,
 South Hadley, Mass. Photo Underwood & Underwood, N. Y.

THE BYRON SMITH BUILDING, POSTMARKED NOVEMBER 7, 1914. Inscription: **F. Day Exercise at 10:30 (address by Ex. Pres. Taft) Laying of cornerstone at 12. Lunch with Pres. Wool. Alumnae meeting at 2. Alumnae Tea at 4 . . . Love M.** Founders Day in November celebrates the opening of Mount Holyoke in 1837. The Byron Smith Building, on the corner of Morgan Street and Minden Place, was used for student housing.

WILLISTON MEMORIAL LIBRARY, POSTMARKED AUGUST 11, 1966. Inscription: **Dickinson House Dear Louise, . . . I'm in the Guest Rm. until my apt. is vacant. Everyone very nice. Have been to various eating places & to see Dr. Zhivago with various members of the staff. Band concert last nite . . . Love to both, Betty.** (Photograph by Robert Grenier.)

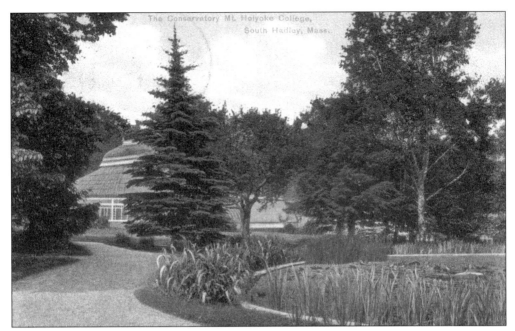

THE CONSERVATORY, POSTMARKED MAY 2, 1911. Inscription: **I'm dreadfully sorry I can't come and see you this vacation. I will come this summer sure. I'm up just for the afternoon seeing about my roommate for next year. Love to all. Grace L. Wheeler.** Grace Leota Wheeler 1916 roomed with Marjorie Seymour Watts 1915 that fall in 14 Safford.

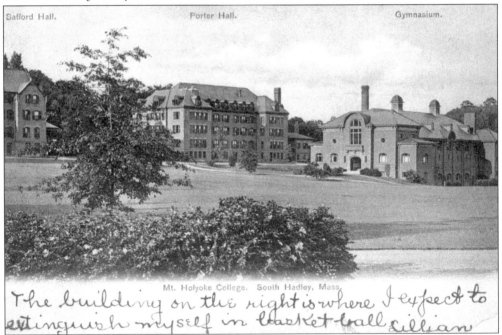

MOUNT HOLYOKE COLLEGE, POSTMARKED SEPTEMBER 29, 1905. Inscription: **The building on the right is where I expect to extinguish myself in basketball Lillian.** The sender of this card was Lillian Ethel Williams 1909, secretary of the Athletic Association and left guard on the 1909 basketball team. She did not expect to expire on the court but rather to "distinguish" herself in basketball.

Six
STUDENT TRADITIONS

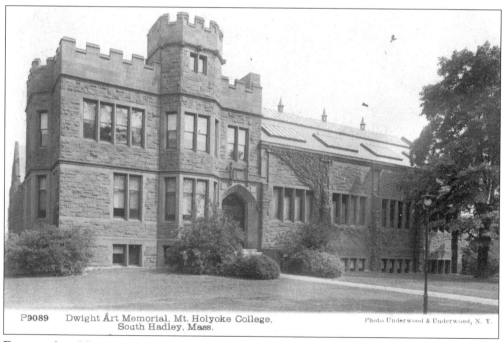

P9089 Dwight Art Memorial, Mt. Holyoke College,
 South Hadley, Mass. Photo Underwood & Underwood, N. Y.

DWIGHT ART MEMORIAL HALL, POSTMARK BLURRED. Inscription: **Yesterday the Juniors spun their tops on the steps of the new recitation building. Monday the Seniors jumped rope. Much love, S.E.S.** Sarah Effie Smith 1886, a mathematics professor at Mount Holyoke, sent this card to her grandmother. The seniors skipped rope while in their graduation gowns during this playful tradition; it was quite a test of agility to get the rope to pass over the voluminous sleeves, which it was not considered fair to pin. The juniors had their own tradition: spinning tops and singing songs at the same time. The "new recitation building" was Skinner Hall, constructed in 1916.

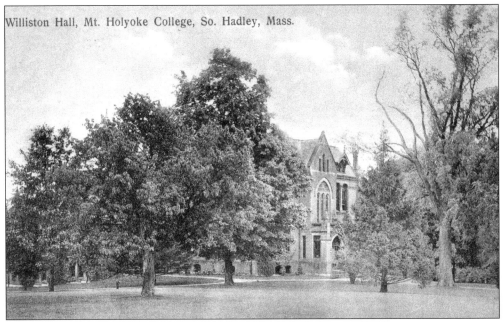

Williston Hall, Mt. Holyoke College, So. Hadley, Mass.

WILLISTON HALL, POSTMARKED SEPTEMBER 28, 1914. Inscription on the back: **Dear Marion. The sole right to sit on these steps belongs to the Seniors. In the spring especially we have sings around here. The Seniors get on the steps, at least as many as can and the rest stand by them. Then the rest of us gather around and we all sing . . . Love Annetta.** Annetta Rebecca Masland 1918 wrote this postcard.

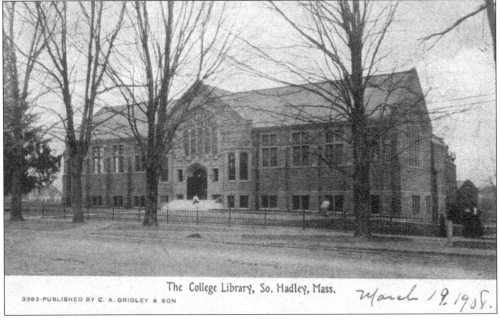

The College Library, So. Hadley, Mass.

3383-PUBLISHED BY C. A. GRIDLEY & SON

March 19 1908.

THE COLLEGE LIBRARY, POSTMARKED MARCH 19, 1908. Inscription: **The score for our game was as follows. Sophomore, 17, Juniors 46. It was a fast & exciting game, but the Sophs couldn't do a thing against the Juniors. They were so tall. Marybelle.** The author was Marybelle Lorella McFeeters 1910.

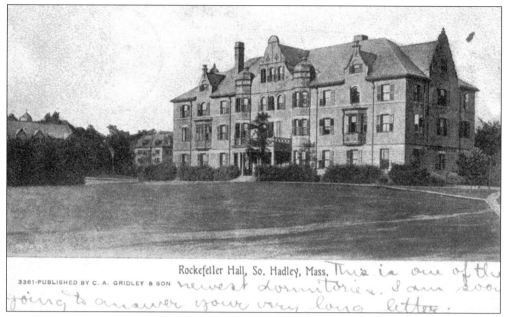

Rockefeller Hall, So. Hadley, Mass.
3381-PUBLISHED BY C. A. GRIDLEY & SON *This is one of the newest dormitories. I am soon going to answer your very long letter.*

ROCKEFELLER HALL, POSTMARK BLURRED. Inscription: **This is one of the newest dormitories . . . Chapel began this morning and recitations begin to-morrow. This evening Catharine Babcock gives a spread at 9.00 P.M. & I am invited. Saturday I am going to the YWCA reception . . . Love to all Dot.** Catharine Weir Babcock x1911 indulged in one of the college's classic traditions: a "spread," or food feast, held in a student's room, featuring food sent from home, often warmed in chafing dishes.

Mary E. Woolley Hall Mount Holyoke College
South Hadley, Mass.

MARY E. WOOLLEY HALL, POSTMARKED MARCH 28, 1953. Inscription: **Hello Johnny—Many of these big girls here at College have Teddy bears and pandas and clowns on their beds! Love A. Polly.** (Published by Robert A. Glesmann and the Albertype Company.)

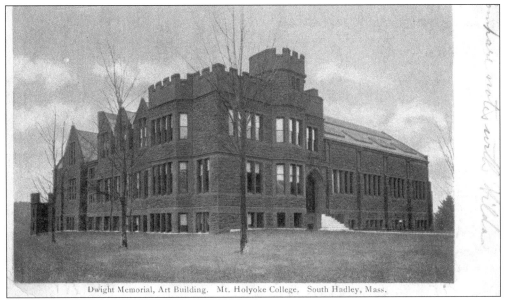

Dwight Memorial, Art Building. Mt. Holyoke College. South Hadley, Mass.

DWIGHT MEMORIAL ART BUILDING, POSTMARKED SEPTEMBER 24, 1908. Inscription: **Dear Ruth: Haven't been hazed or even called "Freshy" What a shame! I am off campus at Mrs. Lyman's famous for her good feeding & motherly ways . . . I am head over heels in love with a soph. Grace MacFarland. My room is the best in the house . . . There are 8 here . . . Helen.** Helen MacFarland Hett 1912 sent this postcard. Grace Newell McFarland x1911 left college early and married in 1910.

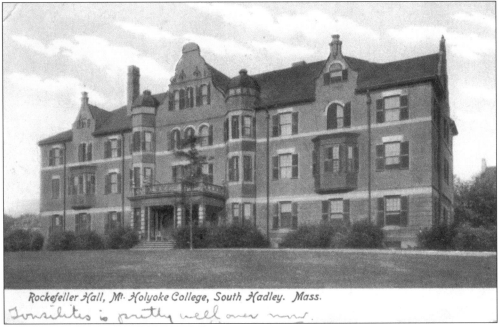

Rockefeller Hall, Mt. Holyoke College, South Hadley. Mass.

ROCKEFELLER HALL, POSTMARKED FEBRUARY 24, 1910. Inscription on the back: **Tonsilitis is pretty well over now. Well we've been so busy here. I haven't had time to write this week. Am feeling grand now. Was a little tired, because we had so much to do. But that wonderful Junior Prom is over now. It was the grandest sight I ever saw . . . Love Rebecca.**

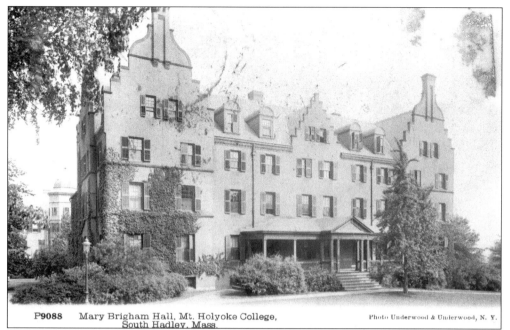

P9088 Mary Brigham Hall, Mt. Holyoke College, South Hadley, Mass. Photo Underwood & Underwood, N. Y.

MARY BRIGHAM HALL, POSTMARK ILLEGIBLE. Inscription: **There are two hundred and fifty girls just in the freshman class. Everyone is lovely and we have some awfully jolly times. It seems more than one tries are worth to get a chance & study, there's something going on all the time. Yesterday we went for a long walk with the juniors who live on the fourth floor. It was great fun. Mina.**

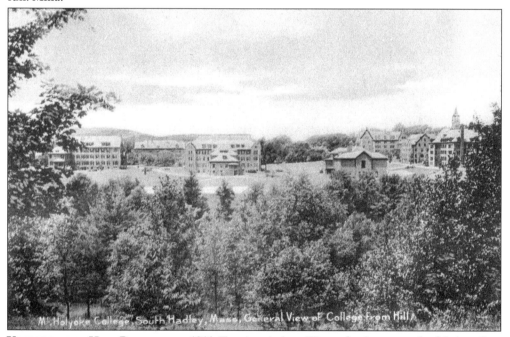

Mt. Holyoke College, South Hadley, Mass, General View of College from Hill.

VIEW FROM THE HILL, POSTMARKED 1911. Two inscriptions: **We are having a wonderful time. Just wish you were here with us. The Junior play was great. F. L. B.** and **We've just come back from a picnic on Prospect. I wish you were here! . . . Lovingly, K.** Junior Show is still a tradition today.

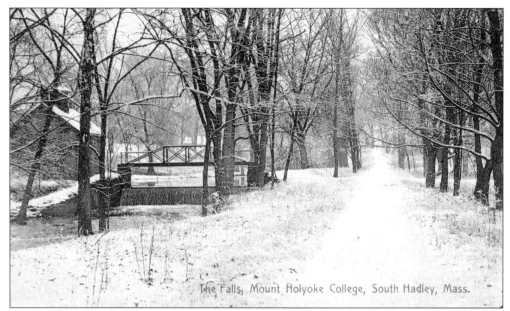

The image reads: The Falls, Mount Holyoke College, South Hadley, Mass.

THE PRESIDENT'S HOUSE, POSTMARKED JUNE 13, 1911. Inscription on the back: **Is not this good weather for the ivy they planted this A.M.? It is proverbial 1911 weather. H____ came over Sunday night for Vespers & I was in Amherst yesterday . . . With love Cathie.** Catharine Osborne Robinson 1911 sent this postcard. Ivy Day was a tradition for the seniors; they would plant ivy next to one of the academic buildings as part of their commencement activities.

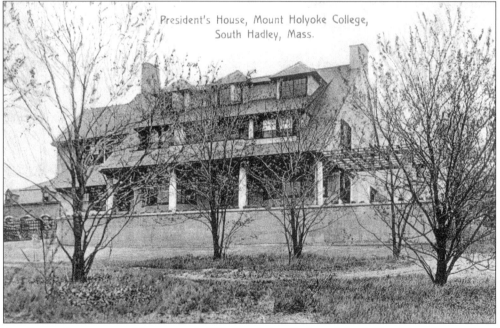

The image reads: President's House, Mount Holyoke College, South Hadley, Mass.

THE FALLS, POSTMARKED NOVEMBER 9, 1915. Inscription: **It doesn't look like this quite yet, but I suppose it will soon. This dam leads to the pond where we have been boating & will soon be skating. To the right is the hill "Prospect" on which we held our freshman frolic Tues. night. H.M. Whittier.** Helen Maria Whittier 1915 sent this card.

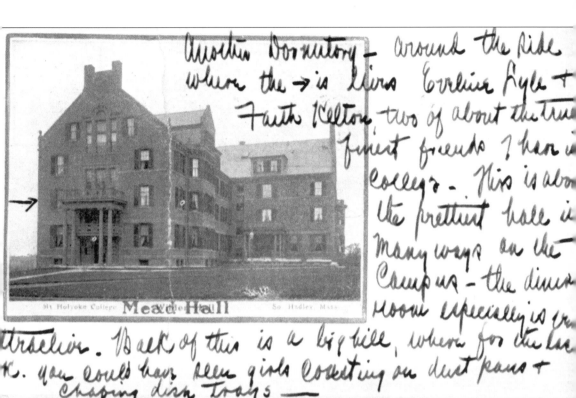

MEAD HALL, UNPOSTMARKED. Inscription: **Another dormitory—around the side where the arrow is live Eveline Lyle & Faith Kelton, two of about the truest finest friends I have in college. This is about the prettiest hall in many ways on the campus—the dining room especially is very attractive. Back of this is a big hill, where for the last wk. you could have seen girls coasting on dust pans & chafing dish trays.** Coasting on brooms, trays, and other kitchen items was a recognized method of recreation dating back to the early seminary days. The Mead Hall stamp attempts to disguise the misprinted Wilder Hall label underneath. Evelyn B. Lyle 1906 and Faith Comins Kelton 1905 lived in 29 Mead during the 1904–1905 school year.

73

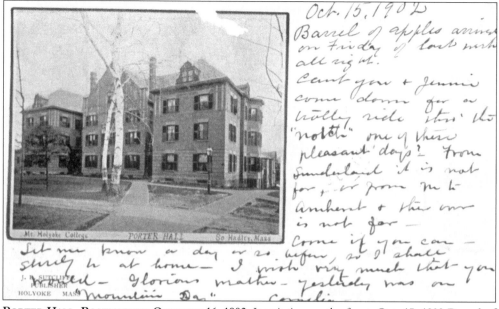

PORTER HALL, POSTMARKED OCTOBER 16, 1902. Inscription on the front: **Oct. 15, 1902 Barrel of apples arrived on Friday of last week all right. Can't you and Jennie come down for a trolley ride into the "notch" one of these pleasant days? From Sunderland it is not far . . . Glorious weather—yesterday was our "Mountain Day" Cornelia—.** Cornelia Maria Clapp 1871 was a zoology professor at Mount Holyoke. On Mountain Day, classes are canceled, and students enjoy the day outdoors.

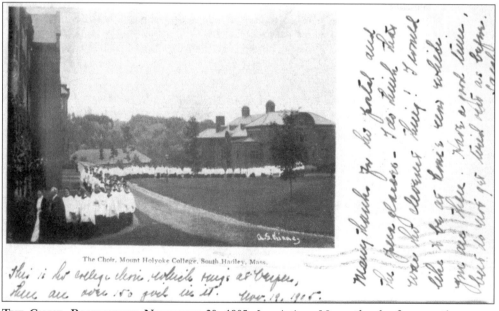

THE CHOIR, POSTMARKED NOVEMBER 20, 1905. Inscription: **Many thanks for . . . the opera glasses—I do think that was the cleverest thing! . . . Have a good time, but do not get tired out . . . This is the college choir, which sings at Vespers, there are over 150 girls in it.** Vespers is a December concert of holiday songs that is still an eagerly anticipated tradition today.

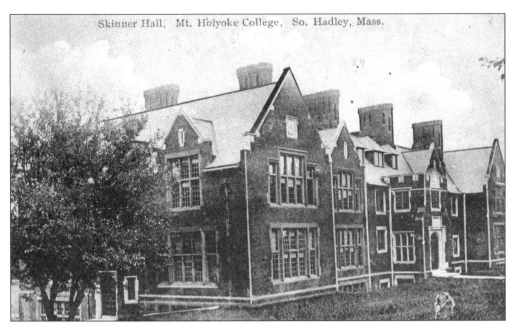

SKINNER HALL, POSTMARK BLURRED. Inscription : **On the other side of the hall are some broad steps. Here the seniors sit . . . while the others gather round them, and all sing college songs and hymns. I went to one of these campus sings yesterday . . . It is all very lovely. Viola.** After Williston Hall burned down in 1917, the steps to Skinner Hall became the Senior Steps.

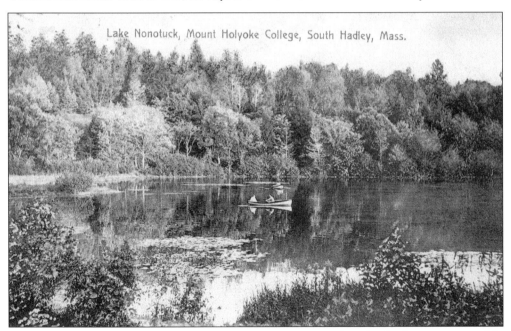

LAKE NONOTUCK, POSTMARKED JUNE 8, 1911. Inscription: **Today the Seniors go up on Mt. Holyoke and stay all night. There is great excitement around here. Give my love to all. Affectionately, Ruth.** Senior Mountain Day was right before commencement. The seniors spent the night at the summit house of Mount Holyoke for festivities. While they were gone, other students would leave notes for their favorite seniors, wishing them well after graduation.

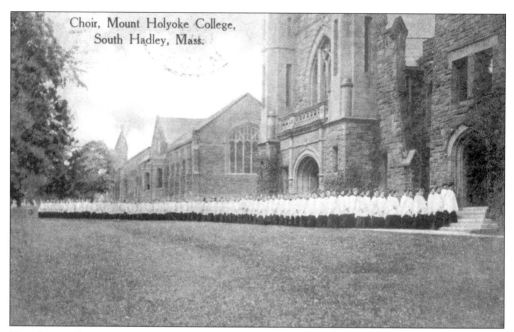

Choir, Mount Holyoke College, South Hadley, Mass.

THE CHOIR, POSTMARKED OCTOBER 9, 1912. Inscription: **I wish you could hear these girls sing. It is glorious—you remember the Englishman who was asked what impressed him most in the U.S., replied "Niagara Falls and the choir at Mt. Holyoke." Am meeting many old friends— the Pageant yesterday was wonderful . . . L.H.** This postcard was sent during the 75th anniversary celebration of the founding of Mount Holyoke.

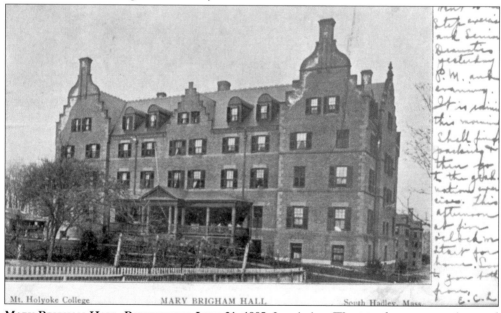

Mt. Holyoke College MARY BRIGHAM HALL South Hadley, Mass.

MARY BRIGHAM HALL, POSTMARKED JUNE 21, 1905. Inscription: **Went to the step exercises and Senior Dramatics . . . Shall finish packing & then go to the graduation exercises . . . E.C.L.** Ella Cecilia Lester 1906 sent this postcard. The seniors had exclusive rights to sit on the stairs outside Williston Hall. At Step Exercises held during commencement week, the seniors passed the privilege on to the juniors, and the two classes sang songs to each other.

Seven
PACKAGES FROM HOME

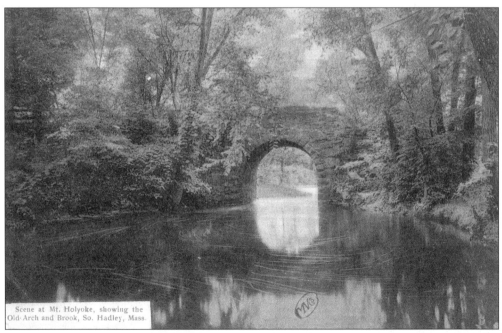

Scene at Mt. Holyoke, showing the
Old Arch and Brook, So. Hadley, Mass.

SCENE AT MOUNT HOLYOKE, POSTMARKED OCTOBER 18, 1907. Inscription: **I spent yesterday studying, going to classes, & setting tables mostly. Also went to a class meeting & to prayer meeting. We voted to have a Soph. picnic next Wed. somewhere. Don't know whether it will be a go or not. Have got through half of this hard day, but guess I shall keep busy the rest of it. Elizabeth & her sister had a suit-case from home last night, with apples, grapes & candy in it, so we are well supplied for awhile . . . Love to all, Edith.** The author was Edith Helen Osgood 1910, who roomed with Elizabeth Mary Mullin 1910 in 18 Rockefeller during the 1907–1908 school year. Elizabeth Mullin's sister was Helen Maria Mullin 1909, who lived in 50 Porter that year.

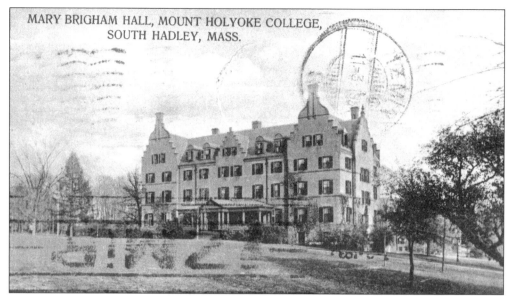

MARY BRIGHAM HALL, MOUNT HOLYOKE COLLEGE, SOUTH HADLEY, MASS.

MARY BRIGHAM HALL, POSTMARKED FEBRUARY 20, 1934. Translated Turkish inscription: **My dear sister, . . . I have received your 18th letter with a $8.00 bill . . . I am very well. I received very good grades and one of the doctors has congratulated me . . . I am on the same level like the American girls here. Regards, Leman Avni.** Emine Leman Avni 1935 lived in Turkey after her graduation.

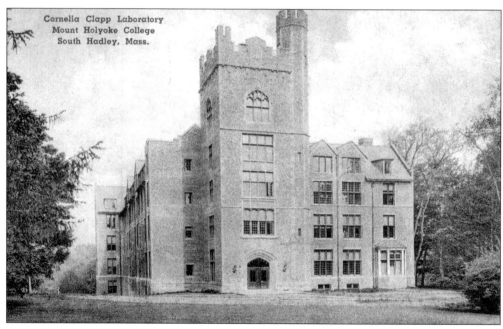

Cornelia Clapp Laboratory
Mount Holyoke College
South Hadley, Mass.

CORNELIA CLAPP LABORATORY, POSTMARKED APRIL 28, 1953. Inscription: **Dear Nellie,—Received your card & you have probably received my letter by this time. The pattern was not in the package. I haven't finished the dress yet. I hope to get at it today. I hope that you find the pattern o.k. Love, Jean.** (Published by Robert A. Glesmann and the Albertype Company.)

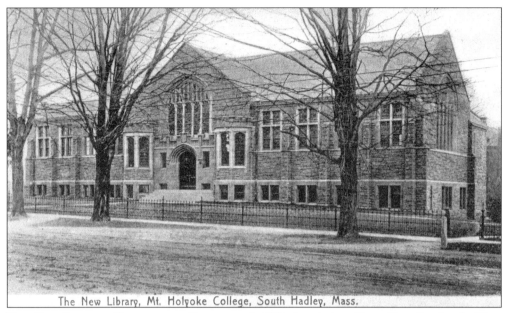

The New Library, Mt. Holyoke College, South Hadley, Mass.

THE NEW LIBRARY, POSTMARKED DECEMBER 6, 1909. Inscription: **Dear Mrs. Southard—That fudge was certainly the best I ever had. I meant to write and thank you for it before. It seems so good to get things from home. How are you all? I'll be there to see you in sixteen days. B.T.** Beatrice Tasker 1912 sent this postcard.

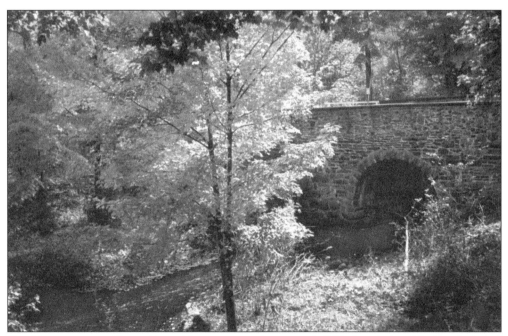

THE BRIDGE BELOW UPPER LAKE, POSTMARKED OCTOBER 2, 1959. Inscription: **Mother dear and Father dear, The "Eagle" arrived today and I am *so* glad to have it! . . . My concert-series tickets came for me today too, so I am all set to see "Measure for Measure." . . . Are you coming up this weekend? Love & kisses to all—Lizzie.** The sender was Elizabeth S. Henry 1962. (A Mike Roberts Color Production.)

SKINNER HALL (REAL PHOTO VIEW), POSTMARKED SEPTEMBER 27 1917. Inscription: **Received the "nightie" yesterday and it is just dandy I should think you might have had it hustle. How's the tatting coming on? This building is where I have most of my recitations. A new one called Skinner Hall. Love to all D.**

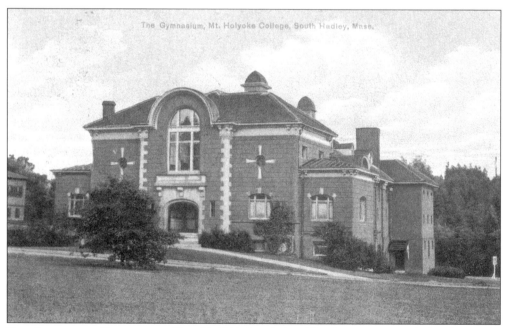

THE GYMNASIUM, POSTMARKED MAY 29, 1911. Inscription: **Thanks ever so much for the candy. Enjoyed it a lot and passed it around at Matties tea-party. Wanted her to meet all the girls and knew of no way to accomplish except by having a tea-party . . . Mattie went at six and since then I've been doing my family letter. Pretty hard to study this hot weather but must do it now for two weeks. Love, [signature].**

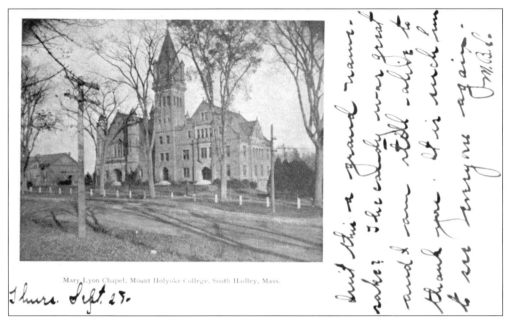

Mary Lyon Chapel, Mount Holyoke College, South Hadley, Mass.

Thurs. Sept. 27.

Mary Lyon Chapel, Postmarked September 28, 1905. Inscription on the front: **Isn't this a grand namesake? The candy was great and I am still alive to thank you. It is much fun to see everyone again. M.B.L.** Mary W. Burdick Lyon 1906 was an associate professor in Turkey after graduation. During World War I, she did canteen work in Paris.

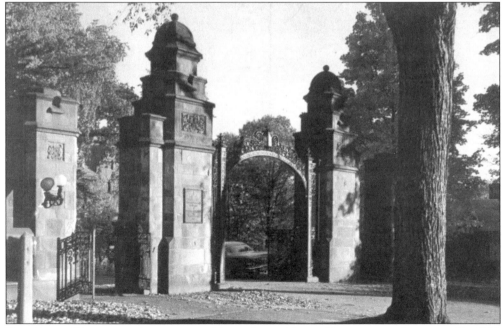

The Field Memorial Gateway to Mary Lyon Hall, Postmarked January 18, 1965. Inscription: **Dear Grandma and Grandpa, Classes end Tues. and exams start Friday. Most of my daily work and all my papers are done. I should start studying for exams but I dread reviewing all the books and notes . . . Thank you very much for the money. You knew exactly what college girls want. Barbara.** (Published by Bromley and Company.)

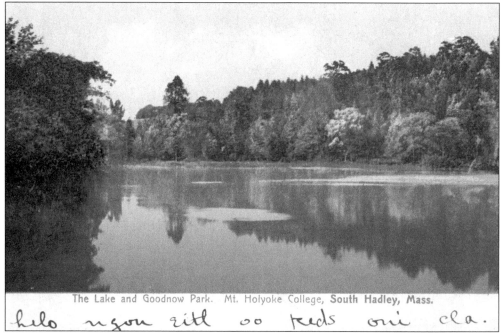

The Lake and Goodnow Park. Mt. Holyoke College, South Hadley, Mass.

helo ngou eith oo teeds oni cla.

THE LAKE AND GOODNOW PARK, UNPOSTMARKED. Inscription on the front: **helo ngou eith oo teeds oni cla.** This could be decoded as "Hello in good health who needs money Claire." The postcard was addressed but not sent.

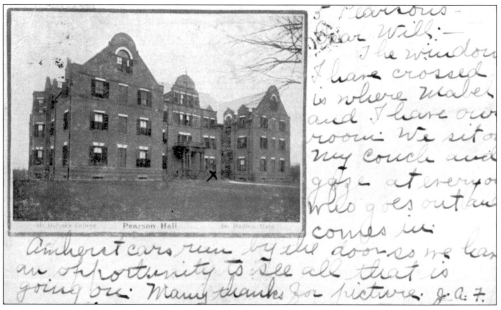

PEARSONS HALL, POSTMARKED SEPTEMBER 10, 1903. Inscription: **5 Pearsons—The window I have crossed is where Mabel and I have our room. We sit on my couch and gaze at everyone who goes out and comes in. Amherst cars run by the doors so we have an opportunity to see all that is going on. Many thanks for picture. E.A.F.** Mabel Louise Comey x1907 and Ethel Augusta Fitts x1907 lived in 5 Pearsons during the 1903–1904 academic year. Note the first-floor window that is marked.

THREE HALLS (WILDER, MEAD, AND ROCKEFELLER), POSTMARKED OCTOBER 8, 1908. Inscription: **Dear Almeda—The books came tonight and will be brought over to Wilder tomorrow AM. Thanks for sending them. I may be home sometime next week Tuesday or Wednesday. Lovingly, Marion.** Marion Flint Buck 1909 lived in 27 Wilder that year. Later, her daughter attended Mount Holyoke.

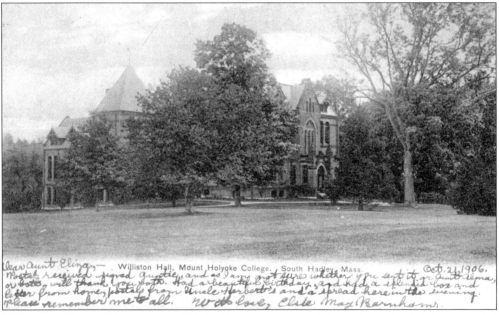

WILLISTON HALL, POSTMARKED OCTOBER 25, 1906. Inscription: **Dear Aunt Eliza,—Postal received signed Auntie, and as I am not sure whether you sent it or Aunt Alma, or both, will thank you both. Had a beautiful birthday, and had a splendid box and letter from home, postals from Uncle Herbert's and a spread here in the evening . . . With love, Elsie May Burnham.** The sender was Elsie May Burnham 1909.

THE COLLEGE (PRIOR TO THE SEPTEMBER 27, 1896 FIRE), POSTMARKED 1939. Inscription: **Dear Mother—How I hate to break this year's record. But I've got to ask you for some money. My Pay Day bill is for everything—my allowance can't cover it & get me home too—music bill— blah—etc. I've added up everything carefully & if you only send me $5 or $6 I can manage I think. I do hope this doesn't put you in a hole. (Perhaps I better stay home during vacation and wash dishes) Love—Carol PS Call it advance on my May allowance? PS Pay Day is this Sat! 9! Love you.** The sender of this card was Carol Milyko 1941. (Published by the Albertype Company.)

UNIVERSAL POSTAL UNION
(Union Postale Universelle)
UNITED STATES of AMERICA
(États-Unis d'Amérique)
WRITE ONLY THE ADDRESS ON THIS SIDE

MRS. H. E. DEATS,

FLEMINGTON,

NEW JERSEY.

U. S. A.

REPLY POSTAL CARD, POSTMARKED DECEMBER 13, 1918. Inscription: **The laundry arrived last night. Helen has a headache today and is going to stay in bed all day. We will send off some packages on Monday. I want to see the styles in N.Y. before deciding about the dress . . . Marian.** Marian Deats 1920 was the sender of this card. Her sister was Helen Deats 1923.

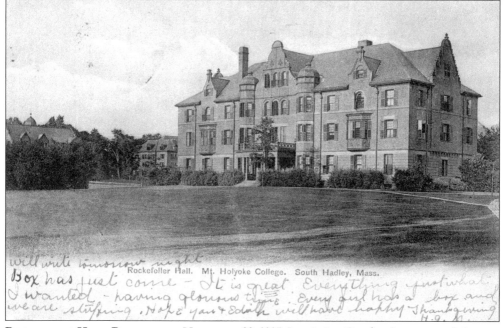

Rockefeller Hall. Mt. Holyoke College. South Hadley, Mass.

ROCKEFELLER HALL, POSTMARKED NOVEMBER 30, 1905. Inscription: **Box has just come—It is** *great.* **Everything just what I wanted—having glorious time. Every girl has a box and we are stuffing. Hope you and Edith will have happy Thanksgiving H.G.M.** This postcard was sent by Helen Gardner Mank 1909. Her sister was Edith Webster Mank 1913. Both women studied at Cornell University and became teachers in Massachusetts.

85

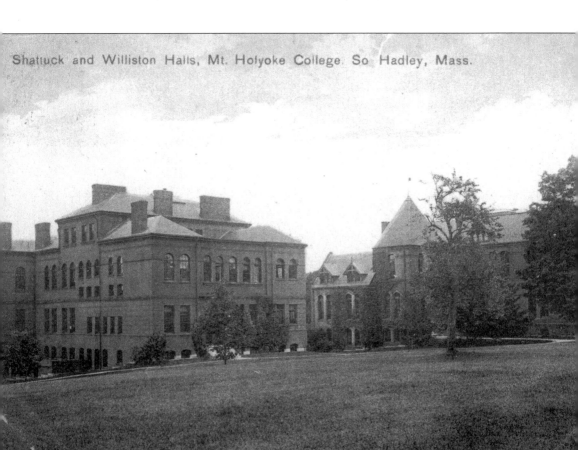

Shattuck and Williston Halls, Mt. Holyoke College. So. Hadley, Mass.

SHATTUCK AND WILLISTON HALLS, POSTMARKED OCTOBER 17, 1907. Inscription: **Dear Momma, My suitcase came all right, and I got the 5:00 car, and had plenty of time to set my tables. I was too tired to study last night and so was Elizabeth, so we went to bed and nine, and slept through all the retiring bells. Feel fine this morning. Got up and set tables for breakfast, and have been studying. The frosting wasn't melted, and the cake is fine. The girls like my hat awfully well and so do I . . . I hope you will be satisfied with yours and it will be a good swap. Love to all, Edith.** The author was Edith Helen Osgood 1910, who roomed with Elizabeth Mary Mullin 1910 in 18 Rockefeller during the 1907–1908 school year.

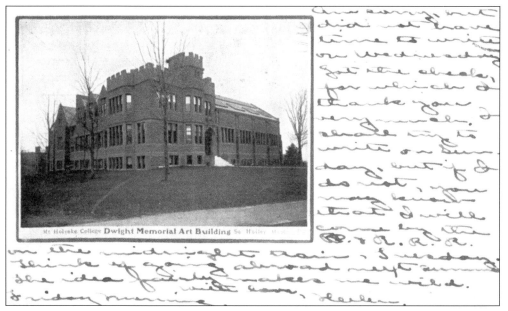

DWIGHT MEMORIAL ART BUILDING, POSTMARKED DECEMBER 15, 1905. Inscription: **Am sorry but did not have time to write on Wednesday. Got the check, for which I thank you very much . . . Think of going abroad next summer the idea fairly makes me wild. With love, Helen. Friday morning.** Helen Emma Wieand 1906 sent this postcard.

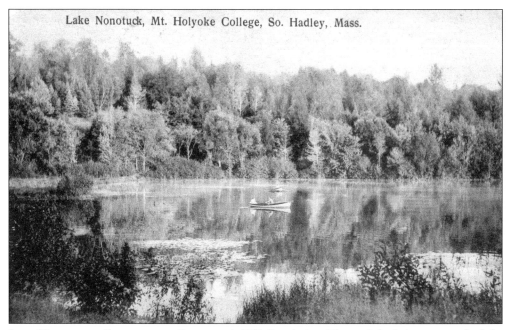

LAKE NONOTUCK, POSTMARKED OCTOBER 4, 1916. Inscription: **I haven't had time to see the lake yet, but shall this afternoon. I am in a nice new hall, where they are all Freshman. Later: Papa & Mama just came in . . . They brought me the loveliest wicker chair and the nicest little lamp. B.P. 4. Woodbridge** This card was sent by Bernice E. Plumb 1920 to a relative at Wellesley College.

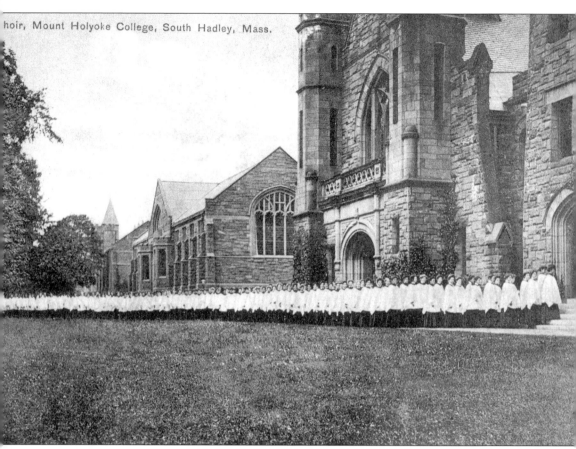

THE CHOIR, POSTMARKED NOVEMBER 10, 1909. Inscription on the back: **Dear Mother,—Your letter, father's and Carrie's certainly rc'd a cordial welcome, tho' the receiving line didn't wear long white kids. I did send father the name of the owner of the brick-plant and his address but will find out again as I've forgotten. Thanks lots to him for the money. The girls are in Vesper Choir surpluses here. I'm not in—Yet—but Soon. Every one laughs when I mention it here, but they won't when I do the solo parts and pay a dollar to hear me. I'll telegraph when I make it or send word by Adam's Express. Watch for the Delivery Wagon. I don't get home until Wednesday the 22nd. Don't bother to [pack?] up parlor curtains but have some choc. almonds and keep the minister. Lots and lots of love, Eleanor.** Eleanor Coover Logan x1913 served as a missionary in China after leaving Mount Holyoke.

Eight
PRIDE IN THE COLLEGE

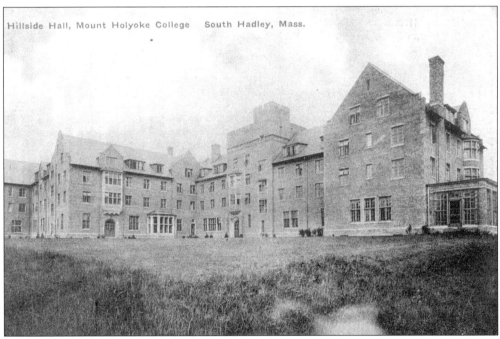

HILLSIDE HALL, UNPOSTMARKED. Inscription: **"Hill" is our other new dorm on the same principle as "Rocky." It was originally named otherwise but the girls during its construction called it Hill so much the administration gave it that name on completion . . . A long board walk leads up the hill to two back entrances. There is a drive "in front" of the postal coming from around the lake. The dorm is really a duplicate of "Rocky" in every way even to the general run of the crowds that go there. It is not as desirous as the other because of its location but many would prefer it to some of the real old dorms near the center of the community. It is the scene of many teas, etc.** "Rocky" refers to Rockefeller Hall. Both Rockefeller and Hillside were built in 1923. Rocky stands in the same footprint as the original Rockefeller Hall, which burned down in 1922. Hillside Hall was built in 1923 at the foot of Prospect Hill and was renamed Mandelle Hall in 1930.

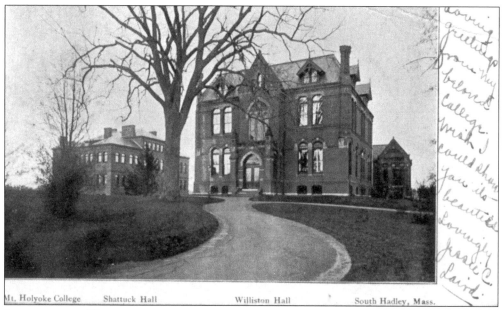

Mt. Holyoke College Shattuck Hall Williston Hall South Hadley, Mass.

SHATTUCK AND WILLISTON HALLS, POSTMARKED MAY 29, 1905. Inscription on the front: **Loving greetings from my beloved college. Wish I could show you its beauties. Lovingly, Jessie C. Laird.** Jessie Cogswell Laird 1906 studied in Germany and Paris after graduation, and she was awarded a decoration by the French government.

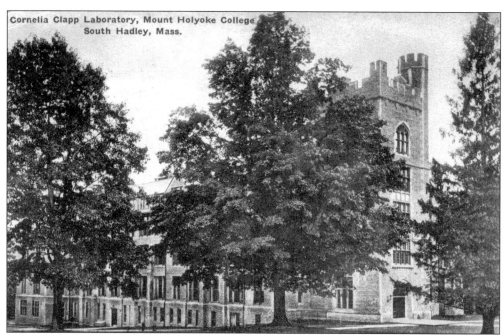

Cornelia Clapp Laboratory, Mount Holyoke College
South Hadley, Mass.

CORNELIA CLAPP LABORATORY, POSTMARKED OCTOBER 31, 1929. Inscription: **This is a very fine science building with well lighted rooms. Speaking of brightness reminds me of the niece, Marcella. She has quite a vocabulary now and talks very plainly. I don't know whether it's safe to tell you on a post card what she calls me. Well, she leaves off the last syllable of my name, the little rascal. Helen.** (Published by A.S. Kinney and the Albertype Company.)

90

THE LIBRARY (REAL PHOTO CARD), POSTMARKED APRIL 10, 1916. Inscription: **Dear Mater, It just occured to me you might be wondering about my cold. It is really all gone, & that's why I didn't think of it. Isn't this a pretty picture of the lib? Love, Peggie.** The sender of this card was Margaret Earl 1916. She was a graduate fellow and assistant in chemistry at Mount Holyoke after her graduation.

THE PHYSICAL-CHEMICAL SCIENCE BUILDING, POSTMARKED MARCH 28, 1953. Inscription: **Hello Tim—There are so many books here you would need a very big bed to put them all in! Love A. Polly.** The Physical-Chemical Science Building was renamed Shattuck Hall in 1954, after the original Shattuck Hall was torn down. (Published by Robert A. Glesmann and the Albertype Company.)

MARY LYON HALL, POSTMARKED SEPTEMBER 24, 1913. Inscription: **Dear Helene, This is the nearest we have to a church. A part of it is our chapel and a part contains offices. This is our first pleasant day since I've been here. The campus is grand. Love, Ione.** The sender of this postcard was Ione Griffin 1917.

ABBEY MEMORIAL CHAPEL, POSTMARKED OCTOBER 9, 1950. Inscription: **This is a picture of our chapel. It is so pretty. I just came from a very nice service there. The work up here is quite hard, but it is loads of fun. My roommate is Vivian Shoods . . . She is swell. Love, Shirleyjane.** Vivian A. Woods 1954 and Shirleyjane Reed 1954 lived in 22 Brigham that year. (Published by Mount Holyoke College Bookstore and the Albertype Company.)

CREST VIEW ON MORGAN STREET, POSTMARKED AUGUST 9, 1910. Inscription: **I am hoping that you have been having a more than beautiful time this summer, and that now the thought of an early return to South Hadley begins to add to the joy of it. Sincerely yours, Flora Bridges.** Flora Bridges was an English instructor at Mount Holyoke. She addressed the postcard to Lois Wilson Woodford 1913. Two sisters lived in Crest View from 1904 until 1930, when the house was sold to the college: Clara Frances Stevens 1881, an English professor, and Alice Porter Stevens 1886, who taught German at Mount Holyoke.

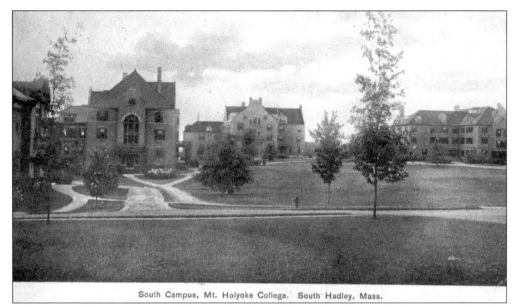

South Campus, Mt. Holyoke College. South Hadley, Mass.

THE GYMNASIUM AND THREE HALLS (WILDER, MEAD, AND OLD ROCKEFELLER), POSTMARKED OCTOBER 2, 1907. Inscription: **Dear Aunt Carrie: I am writing just a few lines to tell you how beautiful it is here. The mountains are grand, and the College Campus is beautiful. I have a nice room and a good roommate. The teachers are very pleasant. With love Catharine R.** The sender was Catharine Osborne Robinson x1911.

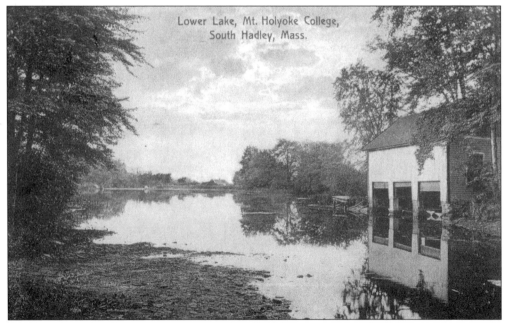

Lower Lake, Mt. Holyoke College, South Hadley, Mass.

LOWER LAKE, POSTMARKED SEPTEMBER 29, 1911. Inscription: **We are too busy with lessons and the various things which are going on in college, to write letters just now . . . This is a most beautiful place. I feel as if I were visiting in the country when I look out of my window to see the mountains and the lake. With love, Almira.** The sender was Almira Lillian Menninger 1915.

94

A CAMPUS WALK, MOUNT HOLYOKE COLLEGE,
SOUTH HADLEY, MASS.

A CAMPUS WALK, POSTMARKED APRIL 25, 1915. Inscription: **This postal is of the walk we call "Rocky Street" for it leads to Rockefeller Hall. The new Skinner Hall which is being built in the other side of the trees & the entrance is where those girls are. The cross shows my Hall. It is lovely here now . . . Ione.** Ione Griffin 1917 sent this postcard. She lived in 28 Brigham that year. Note the small ink cross over Brigham Hall.

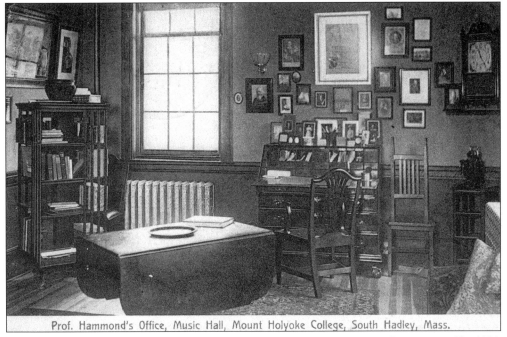

Prof. Hammond's Office, Music Hall, Mount Holyoke College, South Hadley, Mass.

PROFESSOR HAMMOND'S OFFICE IN THE MUSIC HALL, POSTMARKED SEPTEMBER 20, 1911. Inscription on the back: **Dear Ethel: Your letter was received and I certainly was glad to hear from you. Thanks for all you said. My P. O. Box is 577. Isn't "Sea-green" great? This is the best place I've been in ever. Love from Ina.**

95

Approach to Mandelle Hall, Unpostmarked. Inscription on the back: **Mt. Holyoke House Oct. 12, 1935 Dear Mrs. Bills, Wish we might send you a bit of the beauty of the landscape this gorgeous fall day! The trees far below us are like a rich carpet in their autumn garb,—and the old Connecticut only breaks through the loveliness to add a bit of blue to the color scheme. how I wish you might be here to enjoy it with us! Mrs. Carkin has been reviewing and renewing her experiences with the mountain. We really need to hear the experiences of a "fifty-yearer" to make the day complete. We picked up some "color" for you on our early hike around the lake this morning. With sincere wishes B. Cramer.** The card was addressed to Ida Eloise Semans 1885. Mrs. Carkin was Alice Maynard Williams 1909. (Published by the Albertype Company.)

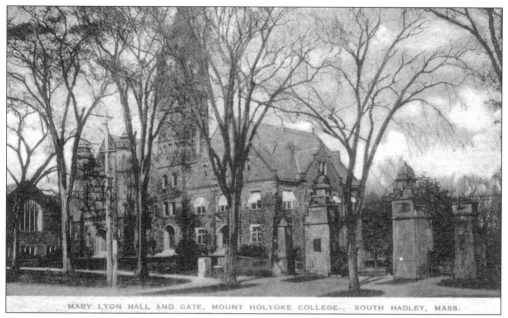

MARY LYON HALL AND GATE, UNPOSTMARKED. Inscription: **Dear folks comprising the Mank household—Greetings from your beloved Mt. Holyoke: I have had many delightful drives around the campus, and always there was the thoughts of you and of the care free days you all spent here. It is certainly a beautiful spot . . . Elizabeth.** Helen Gardner Mank 1909 and Edith Webster Mank 1913 were sisters.

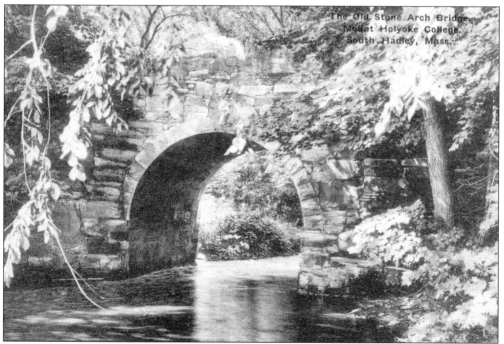

THE OLD STONE ARCH BRIDGE, POSTMARKED SEPTEMBER 24, 1925. Inscription **This is one of the many pretty places near here. The college is certainly wonderful. I'm enjoying myself greatly, and am not homesick at all. Please write. Love, Elizabeth.** (Published by Glesmann Brothers.)

THE UPPER DAM, POSTMARKED JUNE 7, 1909.
Inscription on the back: **I visited Mt. Holyoke College last Friday and had a fine time. There are about 700 girls up there. Yours sincerely Julia.**

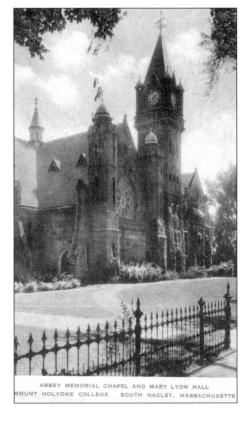

ABBEY MEMORIAL CHAPEL AND MARY LYON HALL, POSTMARKED JUNE 1, 1947. Inscription: **Dear Frank, Elizabeth & I are spending the day here at the college. It is a beautiful place and the lawns & buildings are so well kept. Hazel.** (Published by the Albertype Company.)

GOODNOW PARK, POSTMARKED SEPTEMBER 29, 1910. Inscription on the back: **There is a perfect view of Mt. Tom and the Holyoke range from here. The sunsets are perfect. Come out and see for yourself. Hazel.** The wooded land east of Lower Lake was known as Goodnow Park.

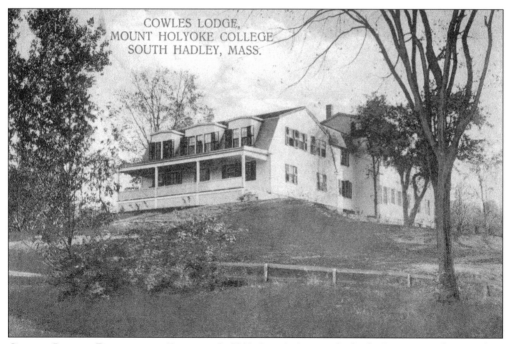

COWLES LODGE, POSTMARKED JANUARY 2, 1913. Inscription on the back: **Dear Grandma, At last we have some postals of Cowles Lodge. Don't you think it looks nice and roomy? . . . Lovingly Esther.** This postcard was sent by Esther Wallace Bicknell 1914, who lived in 10 Cowles Lodge that year. Built in 1910, Cowles Lodge was used for student housing until it was torn down in 1965.

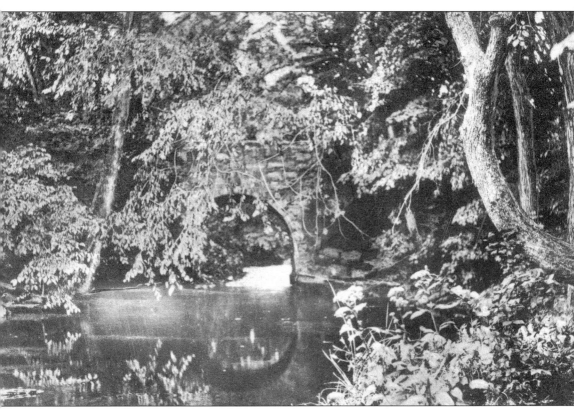

THE OLD STONE ARCH, UNPOSTMARKED. Inscription: **Summit of Mt. Holyoke Saturday Oct 12 [1935]. Dear Mrs. Bills, Just a little greeting from our own "top of the world." Miss Cramer & I are spending the week end in So. Hadley and have driven up here this morning for a view of the Connecticut valley in its autumn glory. The beauty is beyond description. We wish you were here to enjoy it with us! I do hope you are feeling quite yourself once again. When you are as old as I am you will learn to be lazy once in a while and save energy! You know me! With love & best wishes—Alice.** The card was sent to Ida Eloise Semans 1885. The sender was Alice Maynard Williams 1909. (Published by A.S. Kinney and the Albertype Company.)

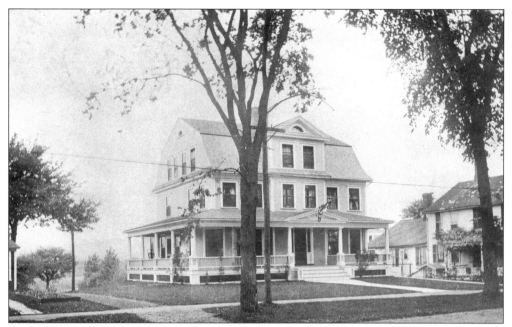

MRS. WINCHESTER'S HOUSE, POSTMARKED SEPTEMBER 30, 1908. Inscription: **This is Mrs. Winchester's house where we are at present. Our room is directly in back of the two windows on the right . . . With love Dorothy.** The sender of this card is Dorothy Flint 1912, who lived in Mrs. Winchester's House that year. Located on College Street, Mrs. Winchester's was used for student housing.

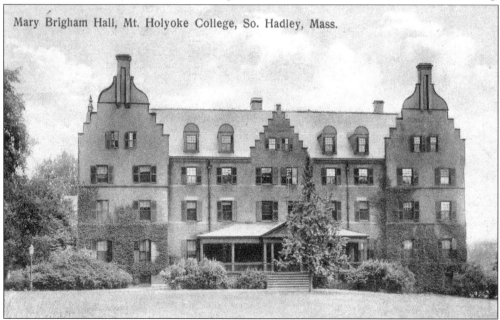

Mary Brigham Hall, Mt. Holyoke College, So. Hadley, Mass.

MARY BRIGHAM HALL, POSTMARKED NOVEMBER 29, 1915. Inscription: **Am visiting Miss Tapley here for a few days. She lives here in this Hall. It certainly is a beautiful college here. Everybody I have met seems so happy and lovely here and the college spirit is of a very fine quality. Sincerely Henrietta Noyes.** Elizabeth Wolcott Tapley 1917 lived in 41–42 Brigham during the 1915–1916 school year.

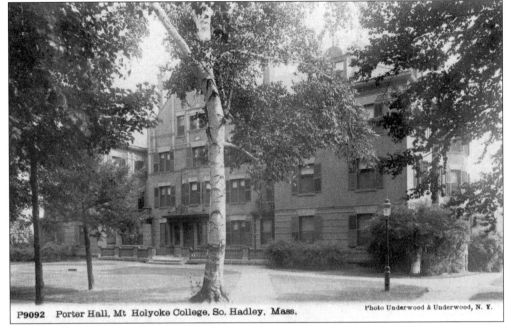

P9092 Porter Hall, Mt Holyoke College, So. Hadley, Mass. Photo Underwood & Underwood, N. Y.

PORTER HALL, UNPOSTMARKED. Inscription: **Another of the College houses. They are all three or four stories high so the poor girls on the top floor get plenty of exercise. There are seven of these big campus houses, beside the gym, chapel, library, art building, music building and chemistry & science building scattered over the campus.**

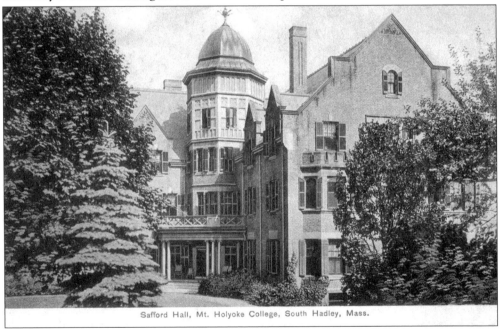

Safford Hall, Mt. Holyoke College, South Hadley, Mass.

SAFFORD HALL, POSTMARKED SEPTEMBER 26, 1908. Inscription: **This is the house I'm living in this year. Isn't it a cute little house? Florence H.D.** Florence Harris Danielson 1909 lived in 10–11 Safford with Adah A. Danielson 1908 during the 1908–1909 school year, and Katharine K. Danielson 1910—apparently another sister—lived in 32–33 Rockefeller that year.

102

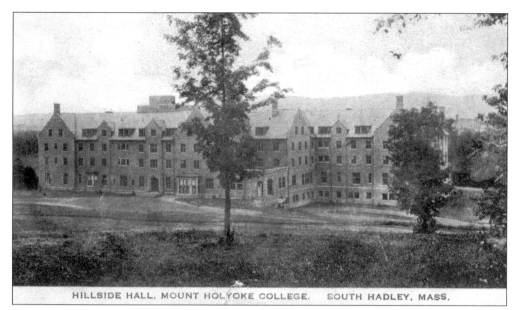

HILLSIDE HALL, MOUNT HOLYOKE COLLEGE. SOUTH HADLEY, MASS.

HILLSIDE HALL, POSTMARKED JUNE 6, 1925. Inscription: **Dear Daisy: How did you get through the heat? This is the new dormitory where they put us. It is very lovely and we are about 37 in numbers so far, more than two thirds of the class . . . E.** Hillside Hall was built in 1923 at the foot of Prospect Hill. It was renamed Mandelle Hall in 1930. (Published by A.S. Kinney and the Albertype Company.)

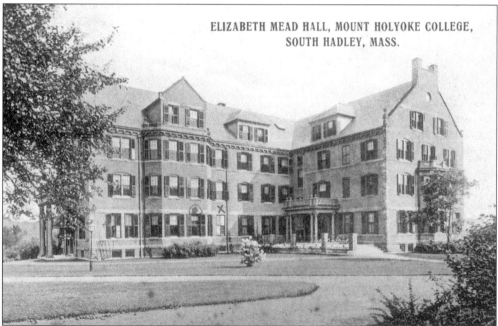

ELIZABETH MEAD HALL, MOUNT HOLYOKE COLLEGE, SOUTH HADLEY, MASS.

ELIZABETH MEAD HALL, UNPOSTMARKED. Inscription: **The X is the room Charlotte Haywood has this year & the O that of Betty Freese . . . You can see Prospect by the side door. The dean lives here . . .** Charlotte Haywood 1919 lived in 4 Mead during the 1916–1917 school year. Her neighbor Mary Elizabeth Freese 1918, whose mother was Grace Eva Gates 1883, lived in 3 Mead. Note the two first-floor windows that are marked.

Mary Wilder Hall, Mt. Holyoke College, So. Hadley, Mass.

MARY WILDER HALL, UNPOSTMARKED. Inscription:
1. When was Mt. Holyoke Seminary founded? 1837
2. When did the Seminary become a college? 1891
3. In what year did the fire occur?
4. What college buildings have been erected since?
5. When was Pres. Woolley inaugurated? 1900
6. Who was "the greatest ad we ever had?" Pres. Mc[Kinley]
7. Which building is the newest? Lib
8. When is Founder's Day? Nov
9. When was the Hartford Association formed?
10. State the Scripture reference on the seal.

This card is inscribed in ink with a Mount Holyoke history quiz. The answers to some of the questions are noted in pencil.

PORTER HALL, UNPOSTMARKED. Inscription: **I live on the reverse side of the reverse side. The view is not distracting nor inspiring, but I have a neat little fire escape for midnite walks in the moonlite. PORTER's really best. Brigham's living room is crummy and Pearson's is too far from everything. You have lost a Jo-Anne and gained a Jone!** (Published by Mount Holyoke College Bookstore and the Albertype Company.)

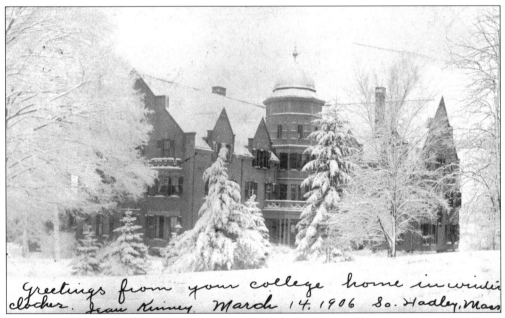

A SNOWY SAFFORD HALL, POSTMARKED MARCH 14, 1906. Inscription: **Greetings from your college home in winter cloches. Jean Kinney March 14, 1906 So. Hadley, Mass.** This card was addressed to Emma Dusinberre Sandford 1892.

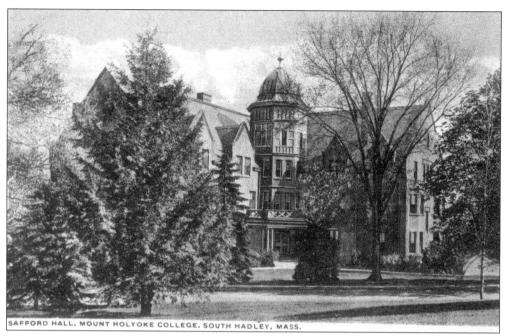

SAFFORD HALL, MOUNT HOLYOKE COLLEGE, SOUTH HADLEY, MASS.

SAFFORD HALL, POSTMARKED JANUARY 27, 1919. Inscription: **This is a picture of the house where I live here at college . . . It is a very nice place, about 65 people living here. I hope you are feeling lots better now. We were sorry to hear that you were ill. Faith.** The sender was Faith Evelyn Harris 1919, who lived in 6 Safford during the 1918–1919 school year.

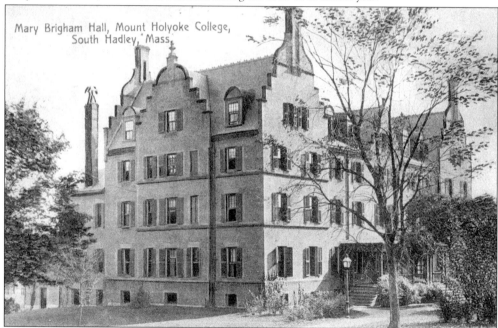

Mary Brigham Hall, Mount Holyoke College, South Hadley, Mass.

MARY BRIGHAM HALL, POSTMARKED NOVEMBER 15, 1910. Inscription on the back: **This is the hall in which I am living. It is a dandy. Corzella.** The sender was Corzella Maria Spencer 1914. Her classmates thought that she had a "Theodore Roosevelt smile." She became a teacher in Massachusetts and died in 1918.

Nine

COME VISIT!

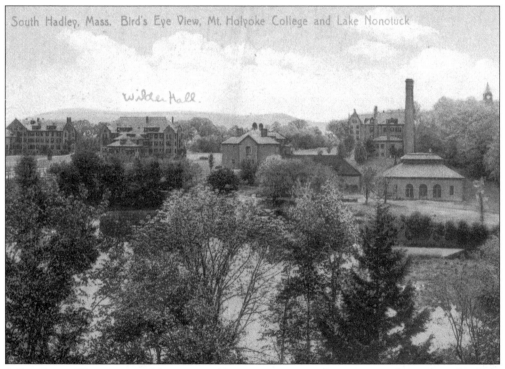
South Hadley, Mass. Bird's Eye View, Mt. Holyoke College and Lake Nonotuck

Wilder Hall.

A BIRD'S-EYE VIEW OF THE COLLEGE AND LAKE NONOTUCK, POSTMARKED SEPTEMBER 25, 1913. Inscription on the back: **Dear Aunt Lucy—I don't feel like studying, so I am putting it off for a few minutes with the good excuse of writing some cards. I have marked my hall, and the lake below is where we row. Mary Lyon Chapel is the tower at the right. I wish you would come down here and let me show it all to you. The tennis courts are in the cleared space at the extreme left below Mead Hall. Have had much fun there today. Lots of love to you & Grandma Gladys. Mt. H.C. Box 536.** The sender was Marian Ella Currier 1916, who lived in 38 Wilder when she mailed this card. Note that Wilder Hall is labeled.

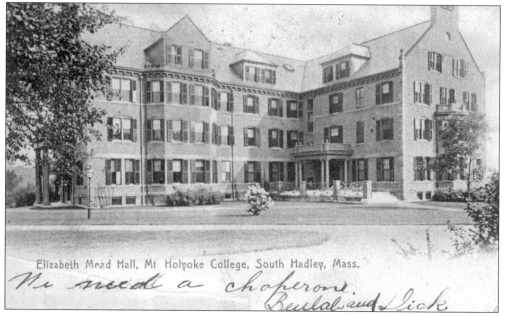

Elizabeth Mead Hall, Mt Holyoke College, South Hadley, Mass.

We need a chaperone.

Beulah and Dick

ELIZABETH MEAD HALL, POSTMARKED AUGUST 5, 1907. Inscription on the front: **We need a chaperone. Beulah and Dick.** Evidently alumnae could act as chaperones for their younger classmates, as this card is addressed to alumna Lillian S. Maclay 1906. Her grandmother Henrietta Caroline Sperry x1847 served as a missionary in China and Japan.

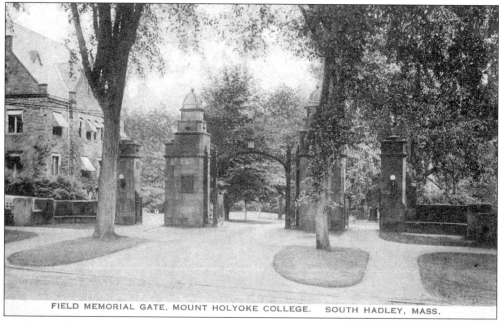

FIELD MEMORIAL GATE, MOUNT HOLYOKE COLLEGE. SOUTH HADLEY, MASS.

THE FIELD MEMORIAL GATE, POSTMARKED JUNE 6, 1925. Inscription on the back: **Dear Ned: I hope you may see this lovely place some day, when it is full of life as it is to-day. The heat is terrible we are trying to forget it. With love from Grace.** (Published by A.S. Kinney and the Albertype Company.)

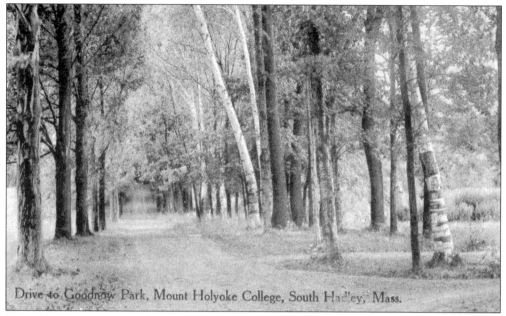

THE DRIVE TO GOODNOW PARK, POSTMARKED SEPTEMBER 18, 1912. Inscription: **This road leads across an arched rustic bridge, to and winds around a hill, where our out-door amphitheatre is, and in the spring in the pine groves—on the top of the hill is a summer house, where lovers can sit and hold hands. Lovingly, Alice.** The summer house is the Pepper Box, a pavilion on Prospect Hill, where students gathered for picnics. The pavilion was torn down in the 1920s.

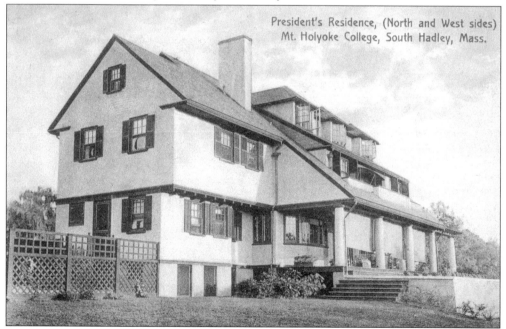

THE PRESIDENT'S RESIDENCE (NORTH AND WEST SIDES), POSTMARKED OCTOBER 21, 1916. Inscription: **My dear cousins: I'm right in the midst of work. But I like it a lot. Some day when I feel real brave I'm coming to this house to see Miss Woolley, the President. She is wonderful. Try to come up to S____ some time. Lots of love to you all. From Edith.**

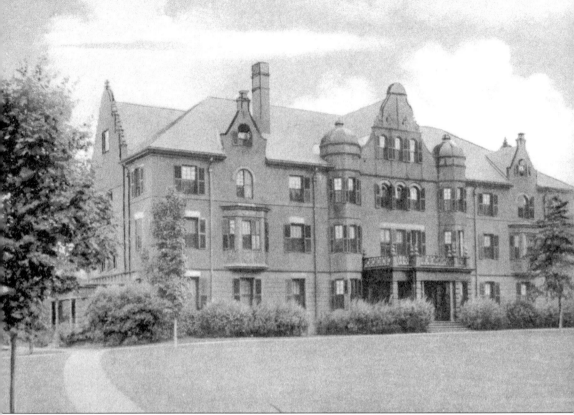

ROCKEFELLER HALL, POSTMARKED APRIL 26, 1913. Inscription on the back:
1. You have no idea how much I miss your fairy footsteps. B.H.P.
2. It is your turn to be *opposite* & I'm doing the s . . . for you—you bad girl (Jud).
Fish, fish, Lucky to miss it. A.P.H.
I hope it is cooler there than here. R.D.
Please bring a sample moonshine back with you. D.J.
I sampled some today!! M.L.
Only room for my name—Charlotte
New kind of dessert to-day Monday
Howdy Woody! You could have been opposite me all week. Miss Sleeper misses you D.D.
Me too Grace.
Hello Woodie, we're wondering when you are coming back. J.M.
We're having dessert I hope you haven't deserted us. W.C.
Woodie may not have received what appears to be a get-well postcard since it has no address.

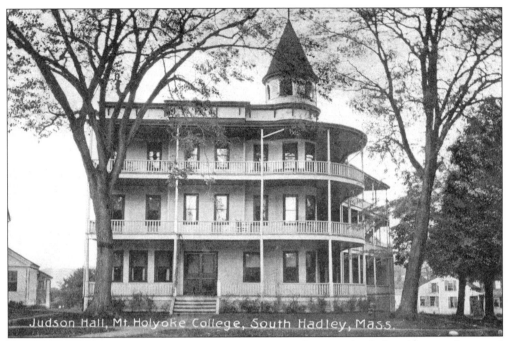

JUDSON HALL, POSTMARKED APRIL 4, 1913. Inscription: **Wish you and Ethel could come down and see us. There is no mud any where here it is so sandy there can't be any. Nat is going to drive team on road machine today Anna.** This handsome building, formerly the Hotel Woodbridge, served as student housing between 1908 and 1932. The South Hadley post office stands on this site today.

HITCHCOCK AND BYRON SMITH HOUSES, POSTMARKED OCTOBER 22, 1917. Inscription on the back: **Dear Mr. Merrick, Will expect you the night of the twenty-seventh. Please call at Hitchcock (the one with the cross) as indicated in this picture) Sincerely yours Emelyn S. Bidwell.** The sender was Emelyn S. Bidwell 1921. Located on Minden Street, both Hitchcock and Byron Smith were used as student and faculty housing.

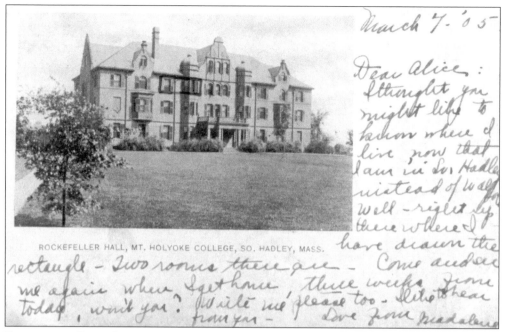

March 7. '05

*Dear Alice:
I thought you might like to know where I live now that I am in So. Hadley instead of Wall. Well—right up there where I have drawn the rectangle—Two rooms there are— Come and see me again when I get home, three weeks from today, won't you? Write me please too— I'd like to hear from you— Love from Madalene*

ROCKEFELLER HALL, POSTMARKED MARCH 8, 1905. Inscription: **I thought you might like to know where I live . . . Well—right up there where I have drawn the rectangle—Two rooms there are. Come and see me again when I get home,** *three* **weeks from today, won't you? . . . Love from Madalene.** Note the third-floor window that is marked. Madalene Lewis 1906 lived in 32–33 Rockefeller that year. Her two daughters attended Mount Holyoke.

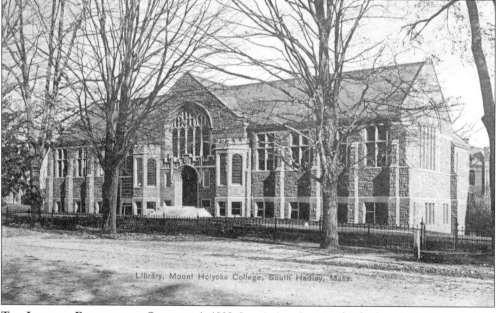

THE LIBRARY, POSTMARKED OCTOBER 1, 1908. Inscription: **Just to think, dear little Frances that** *you* **and** *your mother* **came to call when I wasn't at home. I looked all around the campus for nearly an hour, and nowhere did I find a little girl in a white bonnet or** *pink blouse.* **Maybe you'll come again. I hope so. Tell your mother how sorry I was. Love to Ruth Clara.**

College Street, So. Hadley, Mass.

3382-PUBLISHED BY C. A. GRIDLEY & SON

COLLEGE STREET, UNPOSTMARKED. Inscription: **I'd like to have you come over some Tuesday or Wednesday A.M. . . . It's terribly hard over here and I'm having a hard time trying to keep up. The water is so low here that if we don't get rain in 2 weeks, college will have to close . . . Amy B. Lindsey.** The sender was Amy Blaney Lindsey 1914. Her mother was Hannah Frances Dickinson 1883.

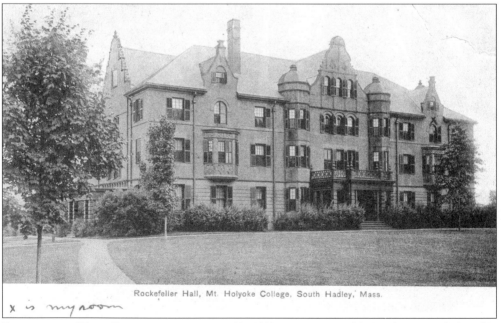

Rockefeller Hall, Mt. Holyoke College, South Hadley, Mass.

X is my room

ROCKEFELLER HALL, POSTMARKED JANUARY 13, 1908. Inscription: **This is where I'm living this year. As soon as the weather gets good you ought to take your family & your auto and come out here on a tour. It's just lovely, and I can show you a whole room full of the grandest old fashioned dishes . . . Mildred B.B.** Mildred Broadhurst Battles 1910 lived in 28 Rockefeller that year. Note the third-floor window that is marked with an X.

CREST VIEW, POSTMARKED AUGUST 10, 1908. Inscription: **Do come if you can any time before the 24th . . . Trolley to Worcester is 2 1/2 hrs. I think not over 3, and 3 1/2 to Springfield: 1 1/2 to S. Hadley. Quite a hard trip! . . . With love E.P.C. My home for the last two years.** Emma Pease Conner was assistant to the registrar. The house, Crest View on Morgan Street, was used for faculty housing.

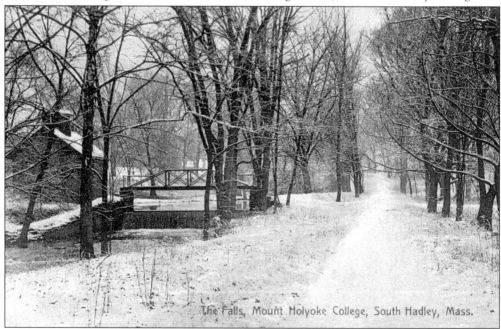

THE FALLS, POSTMARKED DECEMBER 11, 1915. Inscription: **Dear Amelia, This is one of the popular walks when one is fortunate enough to find "someone" to walk with. You had better walk up here someday when you are out for some exercise. Would be very glad to see you off. Mary C.**

Ten
ALUMNAE ON CAMPUS

THREE HALLS (MARY LYON, SOUTH COTTAGE, AND BRIGHAM), POSTMARKED OCTOBER 5, 1910.
Inscription: **I have thought many times of writing this last week but couldn't seem to find the time. Helen went to the Hol. City Hospital last week Sun. and has [been] operated on for appendicitis Mon. She has gotten on beautifully couldn't have done better. Hasn't sat up yet but hopes to as soon as the stitches are out. Hope she can come home by Sunday. Love to all— C.N. Gaylord.** Clara N. Smith 1878, daughter and sister of Mount Holyoke women, is the sender of this card. Her daughter Helen B. Gaylord 1909 must have healed well from her appendicitis, as she went on to have at least five children, one of whom attended Mount Holyoke. The card was sent to Alice Choate Woodbury 1906, a student at Simmons College, who perhaps was living with her parents; the address is next door to the home she would live in 30 years later.

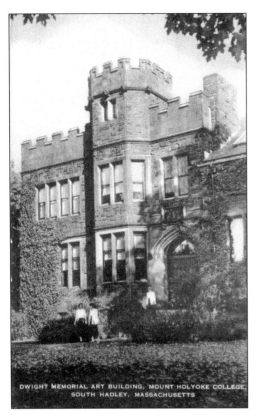

DWIGHT MEMORIAL ART BUILDING, MOUNT HOLYOKE COLLEGE, SOUTH HADLEY, MASSACHUSETTS

THE DWIGHT MEMORIAL ART BUILDING, POSTMARKED JUNE 4, 1962 Inscription: **Dear Helen, You were a *dear* to share your trip so generously with Gladys and me . . . I am back at college for my 50th, a delightful experience enhanced by this perfect weather. Mary R. Walton.** Mary Rebecca Walton 1912 sent this postcard, which has in the banner of its postmark "Mount Holyoke 125th Anniversary." (Published by Artvue Post Card Company.)

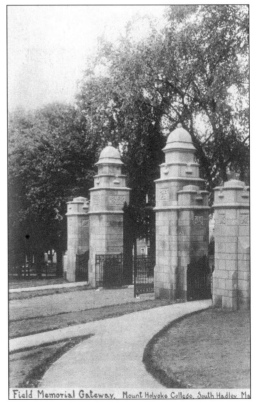

Field Memorial Gateway, Mount Holyoke College, South Hadley, Ma

THE FIELD MEMORIAL GATEWAY, POSTMARKED JUNE 14, 1921. Inscription: **Dear Grace I wish you could have come back to this reunion for it's being the best ever—I'm going to write you all about it. The campus is *beautiful*. Have you seen this gateway? Lots of love. [smiling stick figure].** This postcard was addressed to Grace Elvina Hadley 1904, a former instructor of Latin at Mount Holyoke.

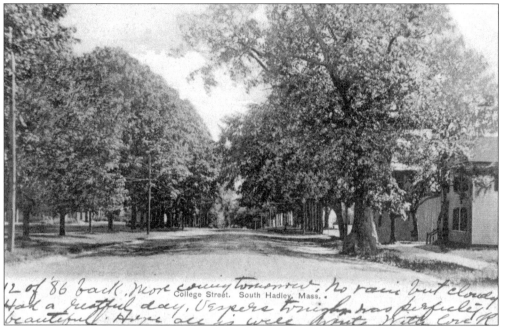

COLLEGE STREET, POSTMARKED JUNE 18, 1906. Inscription on the front: **12 of '86 back. More coming tomorrow. No rain but cloudy. Had a restful day. Vespers tonight was perfectly beautiful. Hope all is well. Write. With love R.** Rena Ellen Sweet 1886 mailed this card to her husband.

HERALDS AT A PAGEANT, POSTMARKED MAY 5, 1916. Inscription: **Methuen May 5 '16. Have just returned from a visit to Hudson, N.Y. & Mt. Holyoke. If pleasant, I will call on you Sunday, reaching B.V. about 4-20. I do wish the electric cars went there. Hope all are well. Yours, Florence.**

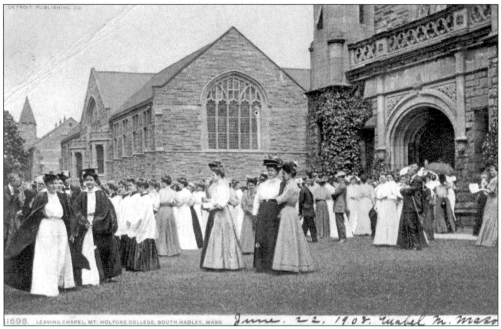

LEAVING CHAPEL, POSTMARKED JUNE 22, 1908. Inscription: **Have been attending my class reunion. Went to Amherst College to hear the class singing. The junior class won the prize . . . June 22. 1908. M.M. Mason.** Mabel Murdock Mason x1883 had a mother and niece who also attended the college.

CLASS OF 1904, MT. HOLYOKE COLLEGE
FIFTH YEAR REUNION

GREETINGS FROM THE CLASS BABY,
RUTH HANA TENNY
45-B BLUFF, YOKOHAMA, JAPAN.

GREETINGS FROM THE CLASS BABY, POSTMARKED JUNE 21, 1909. Inscription: **Wish you could have gone with us Wed. eve. We had fine ride. Alice B.** This postcard was sent by Alice Knighton Betts 1904 to Grace Elvina Hadley 1904. The mother of the class baby was Grace Esselstyn Webb 1904, a missionary who died the following year after giving birth to a son in Japan. The class baby was Ruth Hanna Tenny 1929.

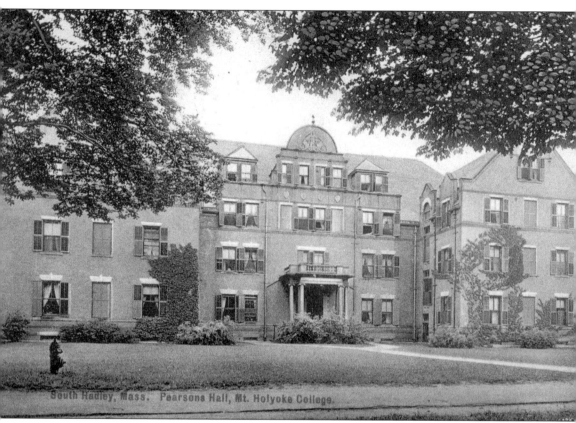

PEARSONS HALL, POSTMARKED JUNE 5, 1911. Inscription: **Dear Mary, We were sorry not to find you at reunion. My best wishes and those of your classmates who were still here when your card came go out to you. You are in the most popular ranks for we have 62 married and 13 engaged. May you be very happy. Yours in '06 L.G.B.** This card was sent by Lottie Genevieve Bishop 1906, who later became vice president of the Alumnae Association and an alumna trustee. She addressed the card to Mary Hewitt Bovie 1906, who married later in the year.

PORTER HALL, POSTMARKED FEBRUARY 17, 1941. Inscription: **Feb. 17th Dear Mother,—I am visiting my sister for a few days here on my way to Orthopsychiatric Convention in New York City Feb 20–22nd. I'm enjoying renewing my college experiences—11 years has changed things somewhat but there are still quite a few people here I know. I hope I can show this section of the country to Aaron soon—he will like it I'm sure. He's keeping bachelors quarters at present but will get along fine I know. Love, Emily PS. This is the hall my sister lives in. I lived in it too my Freshman year.** This postcard was written by Emily Hucker 1930, a social worker in New York and Pennsylvania. Her sister was Marjorie Hucker 1944. (Published by Robert A. Glesmann and the Albertype Company.)

PROSPECT HALL, POSTMARKED JUNE 20, 1962. Inscription: **I'm up here for my 55th college reunion. Our room overlooks this little pond, so that we go to sleep with a frog chorus and awake with the songs of birds. Harriet E. Roe (written at college).** Harriet Eudora Row 1907 sent this card. (Photograph by Bob Grenier, published by Bromley and Company.)

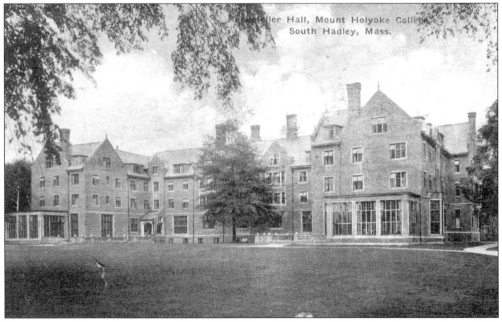

ROCKEFELLER HALL, POSTMARKED JUNE 9, 1929. Inscription: **Lovely day for alumnae day . . . Wish you could see campus. It is lovely. '97 is quartered in Brigham Hall where we lived as the first class after the fire. Several people have asked for Jen & Alice . . . Love to both, May.** Mary Hale Woodbury 1897 and her sister Alice Choate Woodbury 1906 lived with Ezra Woodbury, to whom this card is addressed. (Published by Robert A. Glesmann and the Albertype Company.)

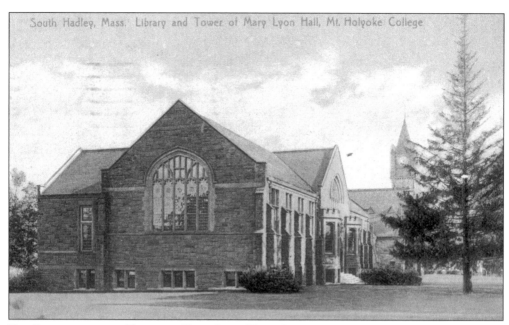

THE LIBRARY AND THE TOWER OF MARY LYON HALL, POSTMARKED JUNE 19, 1921. Inscription: **We were so sorry you couldn't be with us, Grace. We had a splendid reunion. 55 back, so with the '03, 05, & 06's there too, we had lots of visiting to do. The campus & buildings all look more beautiful than ever and it was so good to see the girls again. Alice B.** This card was sent by Alice Knighton Betts 1904 to Grace Elvina Hadley 1904.

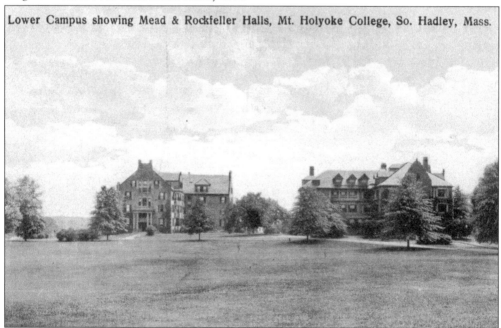

Lower Campus showing Mead & Rockfeller Halls, Mt. Holyoke College, So. Hadley, Mass.

MEAD AND ROCKEFELLER HALLS (LOWER CAMPUS), POSTMARKED OCTOBER 8, 1912. Inscription: **Dear Frances: When I get home I will show you where my room was in Mead Hall. We had a glorious day at college today. With love, Mother.** Ashley Whipple x1903 sent this card to her seven-year-old daughter, Frances.

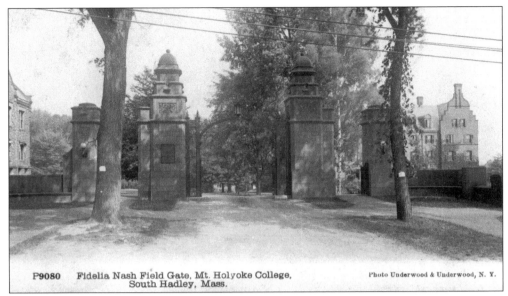

P9080 Fidelia Nash Field Gate, Mt. Holyoke College, Photo Underwood & Underwood, N. Y.
South Hadley, Mass.

THE FIDELIA NASH FIELD GATE, POSTMARKED NOVEMBER 30, 1914. Inscription: **Thank you for your kind thought of Esther. I know she will appreciate it. She has been very, very ill, but just now is more comfortable. What a struggle she has had! Yours with love, S.E. Smith.** Sarah Effie Smith 1886 was a mathematics professor at Mount Holyoke. She sent the card to Mary Alida Goodenough 1886. The sick woman may have been Esther Rice Smith x1880, who died the year this postcard was sent.

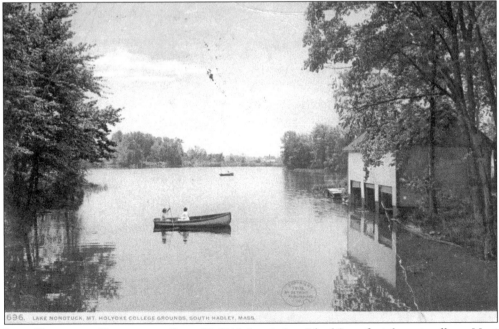

696. LAKE NONOTUCK, MT. HOLYOKE COLLEGE GROUNDS, SOUTH HADLEY, MASS.

LAKE NONOTUCK, POSTMARKED JUNE 12, 1914. Inscription: **I had 2 perfect days at college. Most of the class remained over to-day, but I came Sunday evening. There were 24 graduates out of 44 and 14 non-g. of '89. Your contribution to program was much appreciated. Ida G.G.** This card was sent by Ida Gray Galloway 1889 to Mary Perle Anderson 1889.

123

WOODBRIDGE AND BRIDGMAN HALLS, POSTMARKED JUNE 6, 1931. Inscription: **Am at Woodbridge opposite Rocky. Bad roads to Worcester came through Brookfield Enfield Granby -> So Hadley. Brookfield Inn or a tea room just a little beyond on left looked like nice places to eat. Great fun recognizing class mates & others. Love to all Aunt Helen.** Both of these homes on College Street were used for student housing. Woodbridge burned down in 1969, and Bridgman was converted into a center for the Frances Perkins scholars in 1982. (Published by Robert A. Glesmann and the Albertype Company.)

CLAPP LABORATORY, POSTMARKED JUNE 2, 1958. Inscription: **May 31, 1958 Dear Hazel, Seventy-nine members of my class returned for our re-union, so we are having a wonderful time. Yesterday and this morning the weather was ideal, so it will not matter too much, if it rains tomorrow. With love, Louise.** (Published by Artvue Post Card Company.)

Mary Lyon Hall Mount Holyoke College

MARY LYON HALL, POSTMARKED FEBRUARY 15, 1931. Inscription: **Have had a wonderful time at Graduate Council. South Hadley is beautiful in the winter, I had forgotten how beautiful. Love, Gwen.** This card was addressed to Faith Sanborn 1900.

STUDENT ALUMNAE HALL, POSTMARKED JUNE 11, 1934. Inscription: **Dear Daisy: It was lovely on campus with tents for each class. We went to Amherst for our class banquet . . . Love from Grace. Maude Cobleigh drove out in two hours from Gardner.** The sender mentions Maude Gertrude Cobleigh 1899. (Published by Robert A. Glesmann and the Albertype Company.)

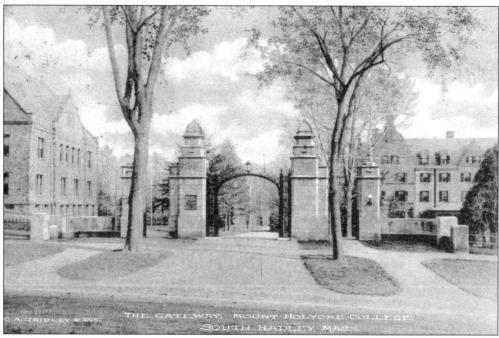

THE GATEWAY, POSTMARK UNDATED. Inscription: **Dear Marion, I wish in some way I might give you an idea of how beautiful it is here. Another 1916 girl and I are back for a few days. I *hope* you can come some day. Lovingly, Dorothy Str . . .** This card was sent by Dorothy Struss 1916.

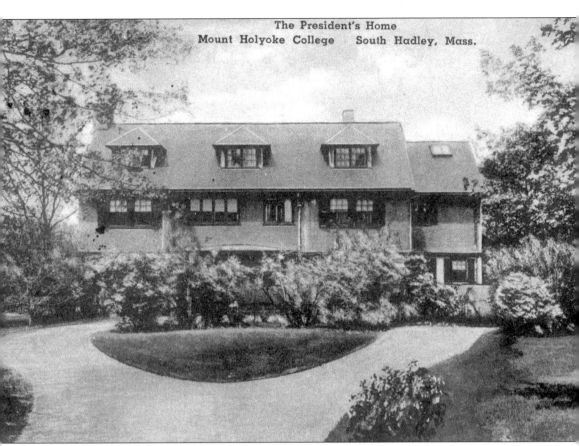

The President's Home
Mount Holyoke College South Hadley, Mass.

THE PRESIDENT'S HOME, POSTMARK ILLEGIBLE. Inscription: **We are having a beautiful time. I got 4 cups & saucers for you. Mrs. Shattuck graduated in 1894. There are six of her class back. I have been talking to a graduate of 1889 who knows all the Cratherns! Have seen several of my own class. I am a *guest* of the college! as a companion to a sixty-year reunioner! Very nice. Going back to Salt Point Monday & home on Tuesday. E. B. S.** The cups and saucers the sender purchased were probably Mount Holyoke Wedgwood, which was very popular in the 1930s and 1940s. Mrs. Shattuck was Emma Dorinda Morse 1894, a former teacher and mother of at least five children. Her mother, two sisters, daughter, and a niece all attended Mount Holyoke. (Published by Robert A. Glesmann and the Albertype Company.)

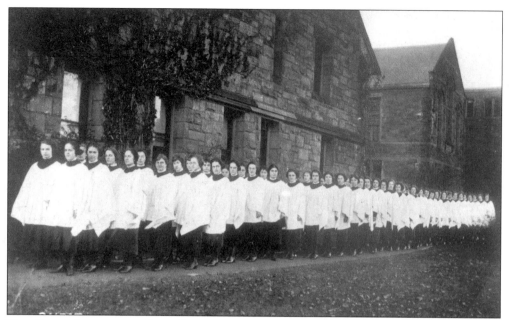

THE CHOIR, POSTMARKED JUNE 15, 1923. Inscription: **We missed you at our 40th. At Betty's suggestion, Springfield Republicans containing reports of commencement were mailed to each absent '83. Upon receiving the papers please notify Mabel Mason.** Mabel Murdock Mason x1883 had a mother and niece who also attended the college. This postcard was addressed to Martha Spencer Brockway 1883.

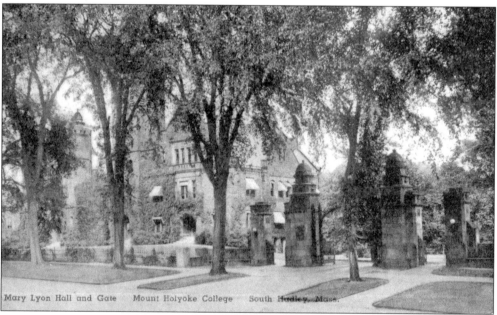

MARY LYON HALL AND GATE, POSTMARKED JUNE 9, 1947. Inscription: **I have been very busy making whoopee here, but will leave after dinner & see you soon. It has rained all the time— guess they think we are ducks or something of that nature. Love Mother.** This card was sent by Harriett Haynes 1922 to her 19-year-old son, Ted, while she was at her 25th reunion. (Published by Robert A. Glesmann and the Albertype Company.)